THE ALLURE OF WOMEN

© 2001 Assouline Publishing for the present edition
601 West 26th Street, 18th floor
New York, NY 10001
USA
Tel.: 212 989-6810 Fax: 212 647-0005
www.assouline.com

ISBN: 2 84323 288 0

Translated from the French by Louise Guiney

Color separation: Gravor (Switzerland)
Printed by Grafiche Milani (Italy)

FRANÇOIS BAUDOT

THE ALLURE OF WOMEN

ASSOULINE

*"Remember that the way we say hello or goodbye gives us
sovereign power over the dream we hope to inspire."*
Louise de Vilmorin

Introduction

A for Art. L for Love. A and L—for Allure. A splendid abstraction, six letters signifying nothing. A word that says it all, but eludes definition. A way of walking? Of behaving? Of appearing to others? Poise, confidence, fascination.

For a little over a century, the game of social appearances is no longer ruled by arbitrary etiquette. It changes with every shift in the weather. A few rare individuals have become weathervanes for each passing decade. They tapped fresh wellsprings of inspiration and were then plundered by other women after them, their particular allure inseparably linked with the era during which they were celebrated.

Beauty, wealth, fame, and elegance may contribute to allure, but none of these qualities is inseparable from it. Some women—and men—simply project a form of unspoken authority. When we talk about them, the word allure rises to the lips.

This book explores this mysterious territory. Explores it but does not ravage it. Completely arbitrary, in no way exhaustive, the juxtaposition of a few freeze-frames enables us to identify movements, points, tangents, invariables— disparate blocks for constructing a certain idea of allure.

Note that allure, as understood here, is the product of the dialogue between fleeting celebrities and those who have made them immortal. From artist to model, from the observer to the observed, no work explaining allure can exclude the people who embody it. Our thanks, in equal measure, go to both the artists and models (or their copyright holders) who agreed to participate.

Feminine Allure

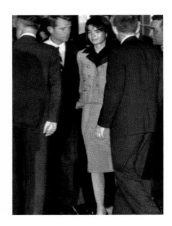

Jackie Kennedy in Dallas following the assassination of her husband, United States President John F. Kennedy, on November 22, 1963.

The more we question allure, the less likely we are to find an answer. Allure is primarily generated by self-assurance. That little core of certainty founded on intimate knowledge of one's qualities and one's flaws. A delicate balance. Because, for a woman, this means being different, while also being true to one's self.

The examples we have selected are, for the most part, wealthy or famous, because they receive the most publicity. But we can safely assume that the allure of these remarkable and remarked-upon women helped them achieve such a high degree of fame and fortune.

Our survey will doubtless seem incomplete. Rightly so. A quality like allure cannot be summed up in a few hundred photographs. In real life, allure evolves in three dimensions, and in motion. This book would have been impossible without the modern, exponential development of image making and the media. In the past, the notoriety of a "beautiful person" ended with the death of their last admirer. Today we can no longer always distinguish which one—woman or image—influences the other.

The reason Jacqueline Kennedy was so admired for remaining herself despite her official obligations, is that all the cameras in the world were pointed at her. This heroine of the modern era knew it. She suffered from it. And then she used it. After the Dallas assassination and until her return to Washington D.C., she continued wearing the Chanel suit stained with her husband's blood. The image of this victim, distraught and yet totally in control, lives on in the minds of all as the absolute model of allure. When she became superrich Mrs. Aristotle Onassis, Jackie continued to demonstrate the same simplicity, the same discretion, the same understated style that had convinced women of her generation that they themselves could adopt her look at a lower cost.

This luxurious understatement won the widow a place on "Best Dressed" lists for many years. The main drawback of the "Best Dressed" system is that it automatically excludes average people, passersby one admires on the street. Fashion columns have long featured only the world's happy few. Today, however, hounded by tax collectors and paparazzi, eclipsed by the stars and starlets of stage and screen, these great ladies have lost much of their authority.

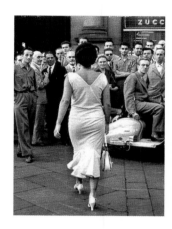

Gli Italiani si voltano, 1954.

The Duchess of Windsor, Wallis Simpson, who coined the maxim "you can never be too thin or too rich," remains the all-time record-breaking champion of the fashion wars, leaving behind her a vast corpus of diverse images and personal belongings. Most of these were sold for fabulous sums at frenzied auctions. Mrs. William Paley, as proved by a host of souvenir photos taken from the 1930s through the 1960s, was another creature who never lost her poise. Truman Capote, who (as most of her close friends) knew her as "Babe," once said of her, "Babe is perfect. That's her only flaw." *Women's Wear Daily* reported, "She doesn't follow trends, she sets them. If she shows up one night at a gallery opening draped in a caftan, the next day most of her friends will be draped in caftans too." And yet, for anyone who cared to listen, Babe Paley always claimed that the essence of her elegance was simply neatness and good grooming.

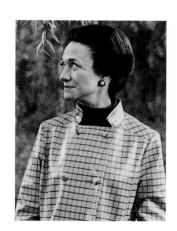

The Duchess of Windsor, circa 1960.

Because the daily practice of hygiene and good grooming were not widespread until very recently, particularly in French society, the word "clean" sometimes suggests a physical and moral virtue. It comes up frequently in the tirades delivered by Coco Chanel on allure. Particularly when the famed designer justified the superiority of the courtesans she knew in her youth due to the fact that, "at least they were 'clean.'" Unlike most proper middle-class women of the time.

" . . . Wallis parts the gray curtains of the dressing room and strolls out to watch the seamstresses, enveloped in their white smocks, as they run up and down the stairs carrying bolts of fabric or dresses ready for delivery.

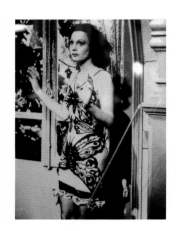

Arletty in Bernard
Deschamps's film *Tempête*,
1940.

"The Duchess always arrived at the salon looking as if she'd just stepped out of a bandbox," recounts Claude Laurent. "She had a curious way of sitting down. She would cross her legs just before lowering herself onto the chair. Her clothes never had the smallest trace of a wrinkle or crease."

"She was perfectly groomed," adds Agnès Bernard. "She was immaculate. That was the hallmark of her personal style" (from the French edition of *Le style Windsor*, by Suzy Menkes, Editions du Chêne, p. 134).

The concept of allure is also inseparable from that of intelligence. Or, at the very least, quick-wittedness. For example, the character played by Arletty in the film *Hôtel du Nord* would be less appealing if the actress's poise, aplomb, and inimitable blend of chic and wise-cracking hadn't contributed to making this little film unforgettable. In the post-Liberation France of 1945, when Arletty was accused in court of having consorted with the Germans under the Occupation, she replied defiantly, "You're the ones who let them in." Snappy comebacks like this, however opportunistic they may seem, don't spring with impunity from just any lips. It takes art and skill to utter them.

Pauline Potter was already a well-known New York fashion designer when she was introduced at a party in the early 1950s to Philippe de Rothschild. "Ah, the poet!" exclaimed the delighted young woman. The impeccable Pauline knew that the baron was also esteemed for his remarkable translation of Shakespeare's sonnets. They were married, lived happily ever after, and had lots of friends. Friends who were invited to share the beguiling lifestyle developed by the new baroness at Château de Mouton in the Bordelais. One guest even claimed that if you fell asleep at Pauline's with your hand hanging over the side of the bed, when you woke up you'd discover your nails had been treated to a manicure.

"One day Fleur Cowles asked the Duchess of Windsor, "If you had to choose a single couturier, which one would it be?" To which the Duchess instantly replied, "The one who'd let me play with the clothes, and who'd be delighted if I made

little changes in the models—and of course the one with the best fitter in Paris." In those days, fitters played the same role in haute couture as pointers do in sculpture. They smoothed out the rough edges. For allure also involves getting things exactly right. Capturing perfection is a primary virtue in the image-hunter.

"Do you mind if I light a cigar?" a parvenu once asked a dowager. "I hardly know how to answer," she replied with imperturbable benevolence, "since no one has ever done so in my presence before."

Allure also depends on the little details which make a big difference: a brief gesture, the wink of an eye, the way the head is carried, an ability to listen, the feminine art of the light touch. It depends on never complaining and not explaining mysteries that would crumble under too much detail. The allure of Diana, Princess of Wales—a big, tall girl with a sketchy education—came from her habit of never looking straight into the camera. Whenever she sensed she was being photographed, she would bend her head slightly and focus on an imaginary point in the distance, as if something entertaining were happening there. In real life, on the other hand, she fixed her big blue eyes raptly on whoever she was talking to. People were totally disarmed, convinced Her Royal Highness was hanging on their every word. In this, at least, the late princess perfectly mastered the skills demanded of royal families by their subjects—who crave allure, and are unforgiving when they fail to find it.

Although she is not considered particularly alluring today, the French will long remember their sole encounter with H.R.H. Queen Elizabeth II of England. It took place at the Louvre, in Paris, at a reception for hundreds of guests, on a fine spring evening during her last state visit to France. Leaning on a balcony overlooking the museum courtyard, recently embellished with Pei's pyramid,

they watched the ballet of motorcycle police and official cars moving in the dark. Suddenly, a huge searchlight pierced the night, beaming down onto a red carpet. President Mitterrand and his wife, in black, remained invisible. And then the queen appeared. Every onlooker, as if examining a Renaissance miniature, drank in the smallest details of her minuscule figure: a yellow gown covered in silvery lace studded with large sparkling diamonds. A necklace and tiara with rubies as large as pigeon eggs. Most of all, a pale gray swan'sdown bolero perfectly matching Her Majesty's hair and face, both entirely powdered white.

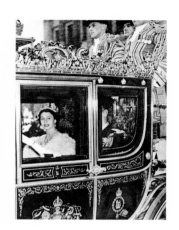

Queen Elizabeth II of England on her Coronation Day, June 2, 1953.

The queen seemed to glide over the carpet, as if it were moving beneath her. She turned her head first to the left and then to the right with a slightly staccato motion. Throughout this brief ceremony, a sustained magnetism was palpable. The French had witnessed the passage of a queen, the allure of an endangered species.

A diametrically opposed example of supreme allure: Inès de la Fressange, who was still serving as ambassadress of charm for Chanel in the 1980s, arrived one day at the Nice airport to find that her luggage had disappeared, and with it, the gown this star model was scheduled to wear, in just a few hours, at a charity ball. She borrowed a gleaming, freshly starched, white shirt from the elegant gentleman escorting her. The shirttails covered her thighs to the knee. Our beauty then found a Provençal scarf and knotted it around her waist, adding a bib of fake pearls picked up at the local Monoprix. With her irreverent wit, Inès caused a sensation that evening, as always. And that's all it takes to launch a new fashion trend: a new attitude, new ways of behaving, a new look for every photo on the cover of *Elle*, like her braided Chanel suit jacket worn over a seaman's jersey and a pair of faded jeans.

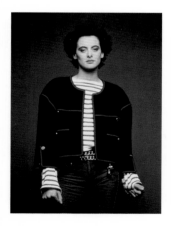

Inès de la Fressange, February 1985.

Allure is also a matter of tiny incidents that become memorable. In a New York

bar, a neophyte fashion reporter was interviewing Maxime de la Falaise, a living archive of fashion history. Understandably a little nervous, the young man spilled his glass of tomato juice over the countess's impeccable cashmere sweater. The countess, without skipping a beat or budging from her seat, simply pulled the sweater up over her head. The young man closed his eyes for a moment. When he opened them again—a miracle! The juice stain had disappeared. Or, rather, it had been turned inside out. Maxime straightened up and resumed the conversation exactly where the glass of juice had broken it off.

Let's not forget that fashion's frivolous beauty and excess inspire serious beauty, and that they there encounter prodigies that remain prodigies, arousing nothing but jeers from those who submit to fashion without understanding its tragic law. Fashion dies. "The only justice it [fashion] can hope for is delayed justice, won through appeal, through remorse." (Jean Cocteau).

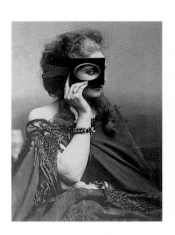

Virginia, Countess of Castiglione, circa 1861.

Live fast. Grab the passing moment on the run! This makes it difficult, as this book goes to press in the form of a tentative analysis, to properly define the allure of the youngest among us. It takes time and distance to evaluate those hints of fashion to come that, having barely arrived, immediately become memories. Allure inevitably fades with the passage of time. Style is as permanent, and crumbling, as the columns of the Parthenon.

Allure, in every era and for every style, has been parsed in the masculine as well as the feminine. But it does not have the same criteria for men as for women. In its virile guise, it must be purely natural. In its feminine guise, on the other hand, it does not, ever, seek invisibility.

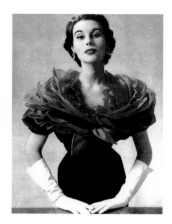

Suzy Parker wearing a
sheath by Givenchy, 1952.

No woman, however discreet, even if elderly or widowed, nun or ingénue,
wishes to pass completely unnoticed. Feminine allure always bears a
hint of the performing arts.

The lovely Countess di Castiglione, having voluntarily exiled herself from high
society under the Second Empire, carefully rehearsed each of her entrances to
the balls given at the Tuileries palace, striving to appear both mysterious and
dramatic. When her star began to wane, she chose to make herself scarcer.
The photographer, Pierre Louis Pierson, left us striking series of portraits
featuring this femme fatale. Time has not totally erased their fascination.
Crowds of people recently gathered to view an exhibition of them:
in Paris, at the Musée d'Orsay; and in New York, at the Metropolitan Museum
of Art. This pioneering "female icon" knew that only the dark room could
ensure her survival beyond her own time. The countess died young and
completely alone. But she was surrounded by photos of her beauty.
How many of the women so admired for their style have left us, marking
their brief passage on the planet Fashion merely with photo images of
themselves? Dorian Leigh, Suzy Parker, Jean Patchett, Christie Brinkley,
Pat Cleveland, Ingrid Boulting, Twiggy—where are they now?
"I've seen orchestras in restaurants strike up a fanfare on the entrance of certain
women. These masterpieces of poise and style sweep our hidden treasures away,
splatter them with the mud of light, relegate our own worst audacities to the
shadows," wrote Cocteau, adding as an example the lovely wife of a Parisian
press magnate Marthe Le Tellier. She carefully staged her entrances on the social
scene and enlisted a squadron of youthful dandies as escorts. She warned them
not to take any notice if they should hear her mutter a few incoherent words
while stepping over the threshold. They dressed in black tie and tails and she
was dripping with diamonds—into the maw of a social occasion fierce as a lion's

den. Turning her head to the right and left with a knowing smile, Madame Le Tel-
lier was just "warming up." Like a dancer exercising before going onstage, she
was preparing to slip effortlessly into conversation or the rhythm of a waltz.

A person intimate with England's royal family informs us that the Windsors used
a similar ploy when they appeared together in public. With the difference that,
rather than murmuring incoherently, they counted. Which requires even less
imagination: (one, seven, twenty-three) . . . "Good Morning Charles!" (eight,
twelve, twenty-four) . . . "How well you look, Granny!" (one thousand two
hundred sixty-three and fifteen hundred fifteen) . . . Smile! (thirty and forty) . . .
Compliment her on her hat . . . Another little nod … And it's back to square
one . . . (and one and two and three and four). If you want to look your best
with the royals, you have to know how to count.

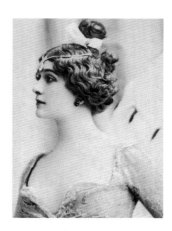

Lina Cavalieri, 1908.

Someone who did not know how to count was the Empress Josephine, a Creole
beauty. She had no sense of numbers and spent vast sums on clothes.
Napoleon—as President John F. Kennedy was later to do with his own wife—
repeatedly warned her to cut back on expenses. After issuing thousands of
warnings, the emperor lost his temper one day, reducing his spendthrift wife to
tears. She promised to mend her ways, and assembled her household staff. "We
must save money," she told them, and for one whole day not a penny was spent!
The dress Josephine ordered that day was really very plain.

There is an undeniable theatrical aspect to allure. In the era of the horse-drawn
carriage, singer and demimondaine Lina Cavalieri was considered one of the
most accomplished beauties of her day when it came to "acting the part." She
was so graceful and so noble that Violet, Duchess of Rutland, mother of Lady
Diana Cooper, continually evoked this former cigar-factory worker of modest
background as the model her daughters should follow. The aging Cécile Sorel,
after having played Célimène at the Comédie Française in Molière's *Misanthrope*

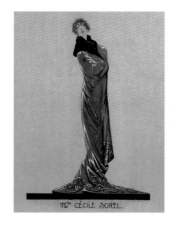

Cécile Sorel wearing a coat
by Jeanne Lanvin, 1923.

as no one ever had before, decided that the only challenge remaining before her was to descend the grand staircase at the Casino de Paris. When she starred in the revue *La Maîtresse du Roi*, a sumptuous spectacle put together by Sacha Guitry, the cream of Paris society sat transfixed on opening night as the celebrated performer, decked out in a regal costume designed by Drian, placed one trembling foot after another on the staircase. The end of the ordeal was greeted by the audience with stunned silence, whereupon Sorel moved to the front of the stage, stared out at the curve of the orchestra seats and addressed her public directly with a never-to-be-forgotten: "Did I get down them all right?" That was all her fans needed. They burst into deafening applause.

The turn-of-the-century allure possessed by women like Cécile Sorel and the Marquise Casati featured a baroque extravagance unimaginable today. Before her marriage to the president of the aristocratic Jockey Club of Rome, Luisa Amon—with her deathly pallor, orange hair and darkly shadowed eyes—was considered a minor personage. Her gradual but relentless transformation took unsuspecting acquaintances by surprise. They observed with wonder as flickering flames slowly kindled in her hair, eyes, conversation, and movements. The marquise became the idol of Gabriele d'Annunzio—the greatest Italian poet of the early twentieth century—and Roman high society vied for invitations to her parties.

It was rumored that snakes climbed the marble walls of her palace above the guests, and that her favorite monkey was allowed to run freely on the grounds. During those madcap years, La Casati was often seen in the street wearing a tiger-skin top hat on her tiny head, or a huge, overturned basket swathed in net or lace. She might appear, during the course of a ball, accompanied by a huge black servant, his body entirely covered in gilt paint, or leading her faithful leopard on a chain. La Casati had no sense of money, and in the early 1900s she

settled in Paris, occupying a replica of the Versailles Grand Trianon. Here was a worthy setting indeed for continuing the costly eccentricities that forced the marquise, in the 1920s, to curtail her extravagance.

She ended her days in London, supported by the generosity of a few loyal friends. But she never abandoned her grand style. In his memoirs, Cecil Beaton recalls a visit she paid him in the country one snowy winter day. She wore a huge cowboy hat, white flannel trousers, and gilt sandals. But Luisa Casati was more than just eccentric. She captivated her era with her allure, her decorated houses, her utterly individualistic behavior, her taste for combining the disparate, and her friendships with artists, interior decorators, and the finest talents of her time. An essential link between symbolism and surrealism, La Casati was even recently used as the inspiration for several themes featured in collections designed by the youthful couturier John Galliano for Dior.

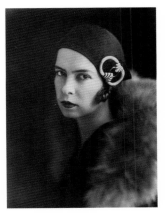

Baba d'Erlanger, Princesse Faucigny-Lucinges, 1938.

This level of excess subsided in the 1920s and 1930s and styles were simplified, although fashion never turned its back on women in the public eye and their innate sense of luxury. "My father supplied a hundred or so pairs of shoes every year to Princesse de Faucigny-Lucinges," recalls the bootmaker Massaro. "He was paid a monthly retainer, and we tallied up the account once a year, in July, just before the summer holidays." Or, again, "In those days, the sky was the limit. I remember, once, we were struggling with a new customer who turned up her nose at every single one of the dozens of models we were showing to her. Then in walked Domenica Walter, a faithful customer and one of the great beauties of the day. She sat down, patiently waiting her turn and taking in the situation. After a few minutes, she stood up and said to my father, 'My dear Monsieur Massaro, I would like to order all the models in this room. Please make them up for me in blue, white, and black." Our troublesome newcomer was naturally pulled down a peg. But the best part of the story is that, when my father telephoned

Domenica Walter to thank her for her little joke, she confirmed the order!"
Wealth was not the decisive factor in the destiny of Lee Miller, born in 1907 in an
upper-class suburb of New York. But elegance, both physical and moral, was.
Returning from her first trip to Paris, Lee was almost run down by a taxi as she
crossed a street in New York. Collapsing in a semi-swoon, the young woman was
caught in the nick of time by a man who inquired politely, "May I ask where you
got the dress you're wearing?" "In Paris," she replied, "where the traffic's a lot
less dangerous than it is here!" "Well it looks terrific on you, please drop in for a
visit sometime soon," said the stranger, handing her his card. His name was
Condé Nast. A month later, she was on the cover of *Vogue*. A host of famous
photographers, including Edward Steichen, George Hoyningen-Huene, and
Horst P. Horst vied to immortalize her boyish, art-deco figure. But Lee didn't
stop there. During a second Paris stay in the 1930s, she became Man Ray's
assistant and a muse to the surrealists, ultimately striking out on her own as
a photographer and winning an assignment as a war correspondent. In 1945,
her photos were instrumental in publicizing the Holocaust. Following the
Liberation—still as alluring as ever, but now matured by experience—she
became Lady Penrose. Thousands of her negatives still sit in trunks stored
in the attic at Farley Farm. Among them is a photo taken by an American G.I.
showing Lee in the Berchtesgaden eagle's nest. Having momentarily shed
her army uniform, she's bathing in Hitler's bathtub.

When Josephine Baker appeared nude on the stage of the Théâtre des Champs-
Elysées on October 2, 1925, she revolutionized all contemporary standards of
beauty, grace, and feminine allure. Subsequently exploiting her vast popularity
on both sides of the Atlantic, Josephine engaged in an unremitting and arduous
struggle against all forms of racism. She was also an early supporter of General
de Gaulle during the Second World War. A staunch member of the Resistance,

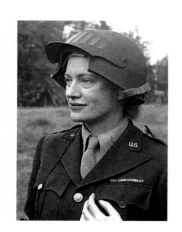

Le mannequin Lee Miller,
devenue correspondante
de guerre, sur le front
de Normandie en 1944.

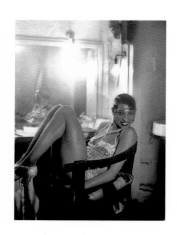

Josephine Baker in her
dressing room at the Casino
de Paris, 1931.

she joined the French Women's Air Force on May 23, 1944 as a "voluntary member for the duration of the war." Josephine threw herself into the war effort with selfless dedication and managed to maintain her natural glamour and verve. As Commandant Dumesnil noted (in *La véritable Joséphine Baker*, by Emmanuel Bonini, Pygmalion, 2000): "Everybody knows you don't wear infantry belts with an air force uniform. But let me tell you something amusing. One day Josephine appeared in my office decked out in an infantry belt that went around her waist and over the shoulders. I asked her what she thought she was wearing. 'But it's prettier this way. I'll be a sensation, won't I?' she answered."

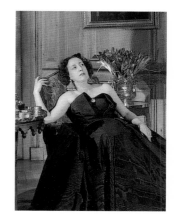

Marie-Laure, Vicomtesse de Noailles, at home in the 1950s.

Marie-Laure de Noailles—one of those rare individuals in whom intelligence, sensitivity, wit, morality, and a touch of impertinence combined, creating an unmatched allure—had Paris at her feet for over half a century. The descendent of the diabolical Marquis de Sade and a powerful dynasty of Jewish bankers, the woman Paris society in the Roaring Twenties dubbed "Marie-Laure" also married into one of France's foremost families. She set the tone, he signed the checks. The Vicomte and Vicomtesse de Noailles willfully flouted all the rules governing the world to which they belonged. In their view, elegance meant recognizing, overcoming, and exorcising the contradictions of the proper society from which they had sprung.

Frivolous and iconoclastic, Marie-Laure became a patron of the surrealists, discovering Balthus, Max Ernst, Salvador Dalí, and others. Her house, redecorated in 1930 by Jean-Michel Frank in an ultra-minimalist style, had Paris society buzzing that the poor Noailles must have been robbed of all their furniture. Architect Robert Mallet-Stevens built them a cubist castle on the side of a rock at Hyères, and Man Ray and Luis Buñuel produced several films financed at a loss by the couple who received and entertained the whole world at

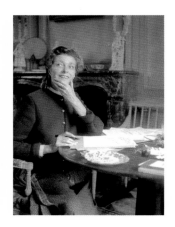

Author and poet Louise de
Vilmorin at her desk, 1955.

their "commune for snobs." Marie-Laure was a fervent supporter of the Spanish
Republican cause and, later, of the Soviet Union. She wore a custom-designed
Cartier ruby and platinum brooch in the form of a hammer and sickle to society
balls. On a trip to Moscow, she decided she had to have a Zill, the car of soviet
apparatchiks. She brought it back to Paris—which was never to see another—
where she drove it herself. Unfortunately, the vicomtesse's dear little red buggy
broke down so often, she finally asked Pop artist César to compress it. "Now it's
worth a lot more," she joked. She joked about everything. Even the fibrous tumor
that ended her life prematurely, exclaiming: "Pregnant! At my age!"

"Marie-Laure was the exact opposite of the Duchess of Windsor," says Jacques
Grange, one of her last admirers. "With the Duchess, appearances were
everything. But Marie-Laure was outlandish, surreal, with her air of Louis XIV in
carpet slippers, her rustic little dresses. She had a quality I never found in
anyone else," explains this connoisseur of art. "She refused to be a slave to
anything. At her house, you'd find fresh apples lying at the base of a bronze
sculpture. She liked postcards as much as artistic masterpieces. She liked to
keep things moving. That's how she kept them alive" (from *Marie-Laure de Noailles*:
La vicomtesse du bizarre, by Laurence Benaïm, Grasset, 2001).

Marie-Laure de Noailles was not a fan of Louise de Vilmorin. And yet, when
she learned of the latter's death, in 1969, she confided, "Louise has just played
a terrible trick on me! She died!"

To her circle of intimate friends, "Loulou" de Vilmorin was simply the author of a
few novels, short stories, poems, and articles. But she had style. Born in 1902,
this heiress of the famed garden-seed company continuously demonstrated her
genius in her active life, rather than allowing it to slumber quietly in her literary
work. She was also one of the most brilliant conversationalists of her time. She
had an intense social life through the 1950s. She was the mistress of Antoine de
Saint-Exupéry, Roger Nimier, and André Malraux and she was the Countess Palfy

for a time. A virtuoso of wit and wordplay, her conversation was as sharp as her profile. It is in the rhythm of her words that we find her true allure—swift, rich, and melancholy. To publisher Gaston Gallimard, who had proposed marriage, she replied with the clever couplet, "je méditerai, tu m'éditeras" (I'll think it over, you'll put me under covers).

Allure is also related to sex appeal. A phrase made to order for Brigitte Bardot. Philippe Collin recalls that in the 1960s, when he was Jean-Luc Godard's youthful assistant on *The Contempt* (filmed in 1963), "We shot all day long in the Villa Malaparte on Capri. The team was mostly made up of young, carefree, skirt-chasing men. The shoot got a lot of coverage in the Italian media, and that made us very attractive to the girls on the island. But where do you think we spent all our nights?

Brigitte Bardot welcoming François Mitterrand (then a Minister in the French government) and Edwige Feuillère to the Cannes Film Festival, April 24, 1956.

"The producers had assigned Brigitte a nearby villa, a big one. But she spent most of her time in the main bedroom and bath. The other rooms—kitchen, huge living room, terrace—were occupied day and night by the guys on the team. One of them cooked. Others played poker or watched TV. Brigitte would sometimes wander into this improvised court, wearing a bath towel tied around her head or a sarong for a "formal" touch. She'd grab a coke from the fridge, flash a big smile, and, with that inimitable lip-pucker of hers, ask if everything was OK. Then, rocking on the balls of her bare feet as only she could do, she'd go back to her room. Followed by the yearning gaze of a couple of dozen guys who could have had all the girls they wanted if they'd just gone out into the streets of Capri. They knew there was nothing doing with Bardot. Except for her presence, her scent, her magnetism, and a feeling of intimacy almost like love. But that was enough for these wolves."

This anecdote explains the power a beautiful, unassuming woman can exert over everyone who meets her.

Marilyn Monroe singing "Happy birthday, Mr. President" to John F. Kennedy on May 19, 1962 at Madison Square Garden, New York.

In 1949, Philippe Halsman, at the time one of the star photographers of L*ife* magazine, beamed his lens on eight of the most gorgeous starlets being groomed to breathe new life into the Hollywood studio mystique. Every one of them, clearly well aware that their future depended on Halsman's lens, struck studied, glamorous poses. Every one, with a single exception.

The one wearing a very plain little shirt dress and who, although standing in the middle of the composition, seemed totally detached—almost indifferent to what was going on around her. The names of the seven other women have long been lost to history. But hers—Marilyn Monroe—was already attracting attention. A living doll who some of the most powerful men of the time sought to protect from her own vulnerability.

Much later, Halsman admitted that the group photo was a terrible experience because of the feigned indifference of that beginner. She spoiled the shoot for everyone. She spent more time than any of the others in front of the dressing-room mirror, adjusting for the thousandth time a strand of hair, her makeup, or the hang of her dress, and held up the whole session.

But the allure was there. "Miss Monroe, what do you wear in bed?"

"Just a few drops of Chanel No. 5." Chanel is still reeling from the shock.

A few years later, she sang "Happy Birthday to you, Mr. President," combining a political act with an overt plea for love from a man who was already moving away from her. During those few minutes, Marilyn Monroe put everything she had on the line and lost.

A different strategy, the same result: a woman—this time of noble lineage—who captivated her entire era. Or at least the top one thousand people who counted in the time between the wars in Paris. Born Daisy Decaze in the United States, the honorable Mrs. Reginald Fellowes served as model for the many women throughout the world who despaired of ever matching her. Brunette, with a good

figure and an impeccable background, her sense of paradox stretched a limitless budget still further, allowing her to do exactly as she pleased. Daisy Fellowes wore her clothes until she wore them out. But always with an air, in even the simplest outfit, of alighting from a luxurious yacht. Or at least, that is how her contemporaries still remember her. Daisy Fellowes liked to throw other women off balance. At gatherings for which the guests had 'dressed to kill,' she'd appear in a little cotton dress. She bought those simply cut, identical little cotton dresses of hers by the dozen, in different colors, and wore them with exotic jewelry, emerald cuff links and brooches, Indian necklaces and diamond conch shells. She even wore jewelry to the beach. Obviously, the desired effect was to make all the other women seem over-dressed and slightly ridiculous" (*The Glass of Fashion*, by Cecil Beaton, Doubleday, 1954). This trend toward studied simplicity, now a constant of feminine allure, reached its height at the end of the 20th century with what fashion editors call "minimalism." This term, borrowed—sometimes unwittingly—from the avant-garde of the 1970s, today describes "poverty" chic for little rich girls. Thus confirming Oscar Wilde's aphorism, "Simplicity is the ultimate refuge of the complicated."

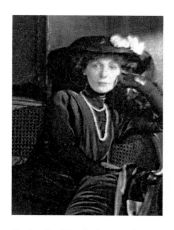

Portrait of Lady Lavery by Baron Adolf de Meyer, 1910.

At the peak of the 1890s, a small group of society women, famous demi-mondaines, and glamorous actresses—often indistinguishable from one another—were the final arbiters of fashion. "There is no nobility without Cartier," the famed Rue de la Paix jeweler liked to say, but when he arrived uninvited at a Rothschild ball, he was told by a respectful but determined butler, "The baron has asked me to inform you, sir, that tradesmen are received only in the morning." London and Paris were microcosms in which everybody knew everybody else. Knowing and being known, seeing and being seen—hierarchies seemingly etched in stone.

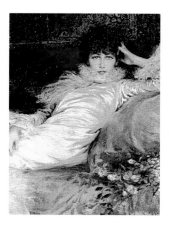

Sarah Bernhardt (detail), by Georges Clairin, 1876.

Each social caste, age group, and circumstance had its own privileges, language, customs, and distinctive style. Insiders navigated a multitude of signposts through a large, complicated social maze.

At the highly official annual "Salon," painters celebrated the woman-of-the-moment and her allure. Meanwhile, the herd of common Parisians perched on metal chairs lining the Avenue du Bois or the Allée des Acacias to gape at the parade of horse-drawn carriages, little duchesses and their chaperones, and great courtesans, all exhibiting an unattainable elegance that was abundantly reported, commented on, and reproduced in specialized magazines. Since fashion photography was still in its infancy, illustration was still the rule. "Our social persona springs from the imaginations of others," Marcel Proust said of the attitudes on which he was soon to confer immortality through his work.

In 1900, allure and the concept underlying this flattering designation, still differed little from what it had been under the Ancien Regime. The stigma of caste, as illustrated by the ravishing child in Greuze's *La Cruche Cassée* or the Parisian gamine with a bandbox under her arm, do not draw on aristocratic criteria. But, with few exceptions, the allure projected by that type of young girl was confined to a specific category: populist, exotic.

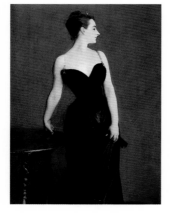

Portrait of Madame X
(Madame Pierre Gautreau),
by John Singer Sargent,
1884.

It required free spirits, the visionary brotherhood formed by the impressionists in opposition to the civility of the time, to extend the concept of allure into an unexplored strata of society. The tutus of Degas's ballerinas, Yvette Guilbert's black gloves, and La Goulue's cancan constituted the first attacks against the rarefied universe inhabited by the women who modeled for Jean-Auguste-Dominique Ingres, John Singer Sargent, Giovanni Boldini, and Paul Helleu.

In 1900, the Duchesse de Guermantes was already overshadowed by Simone Signoret as Casque d'Or, a woman of the people. The cult that developed around Joan of Arc—a girl of peasant origin and the first religious mystic to don men's clothing, according to legend—was never stronger

than during the years when women took their first steps toward liberation. The First World War, a watershed separating the old from the new, trained women to be fighters, to live without men, to live like men. The values of Old Europe were shifting. On the other side of the Atlantic, women had already won certain rights. Allure now belonged to the women who held their heads high. It no longer implied merely feminine grace or privilege, but—for many—authority, dignity, and courage. "Woman is the future of man," declared a great misogynist. But did even he imagine that a woman might become even more beautiful through controlling her own future? As did Chanel—a modest dressmaker in 1920, queen of Paris ten years later, "Mademoiselle," to her staff, "Coco" to her friends, Gabrielle on her birth certificate. Chanel is now recognized as a major orchestrator of 20th-century allure as we know it today.

Other couturiers, past and present, have personally influenced the way women look. But Gabrielle Chanel was not just a couturier, she was a unique phenomenon, molded from the same clay as Pablo Picasso, Igor Stravinsky, Le Corbusier. The Chanel woman marked a turning-point between what had gone before, and what came after. The style she invented was not designed solely for the privileged few. For the first time, it broke with ancestral custom. Allure embodied a revolt against established social rules. The entire fashion system has rested on this new postulate ever since.

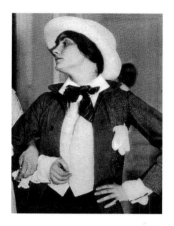

Coco, later to become the fabled Mademoiselle Chanel, circa 1912.

"I can't stand doing what other people tell me to do. I'm like a cat. I follow my own path, the one I've staked out myself, even when it bores me. I'm a slave to it because I've chosen it freely. I'm about as fragile as steel, I've never missed a single hour of work, never been ill. I've escaped from the clutches of endless eminent physicians who have diagnosed me with various mortal ailments I never bothered to treat. Since the age of thirteen, I've never considered suicide" (L'Allure de Chanel, by Paul Morand, Editions Hermann, 1976).

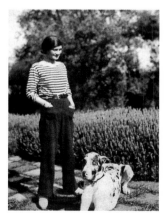

Coco Chanel at her villa "La Pausa" on the French Riviera (late 1930s).

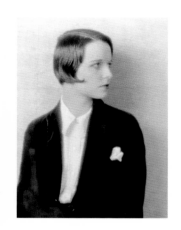

Portrait of silent-film star
Louise Brooks, Hollywood,
1920s.

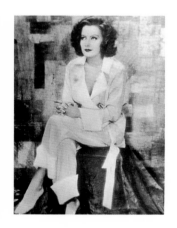

Greta Garbo, "The Divine,"
on set in 1928.

By the interwar period, dewy-eyed ingénues had already become passé in Europe and the United States. Gainful employment, sports, the great outdoors, and a certain type of entirely new freedom irreversibly transformed women's hearts and bodies. Chanel, who was no man's wife or concubine, had a flash of inspiration one early evening. Although planning to attend the opera later, she seized a pair of scissors and cut off her hair. Those thick raven tresses falling onto the tiled floor of Chanel's bathroom made history. Hordes of women followed her lead, radically and instantaneously changing their style. As the popular tune soon filling the Paris airwaves put it, "She cut off her hair/isn't that swell!/It's dandy, it's handy/She cut off her hair/Now she's slick as a bell." Chanel's version of feminine allure—often copied, infinitely varied, deconstructed, revisited—blew the lid off her own time, relegating it to the past. Meanwhile, on the other side of the Atlantic, another bloodless revolution was in progress. This was the emergence of "the consumer society," analyzed with a combination of horror and resignation by European sociologists in the 1960s. Drawing on the "American Way of Life," a new mood took hold in Europe following the Liberation. "Beauty American-Style Is Yours for the Asking," headlined the *Figaro Illustré* in 1948. The American woman—with her gleaming bathroom and impeccable grooming, her access to functional and easy-to-wear clothes—began to appear in Europe during the 1950s, offering a standard of feminine allure for which Hollywood stars had long served as the effective models and popularizers. American movies, dreams "Made in the U.S.A.," were the best propagandists in the Old World for the new-world Yankee style. They held out a golden opportunity to all to be someone, to exist, outside of rigid social categories. Through individual merit, individuality. As reflected in the name of the French discount chain Prisunic—with its key evocation of the word "unique."

The movie-star image, a product manufactured by the major Hollywood studios—MGM, Warner Bros., Howard Hughes, etc.—cast its spell over the entire

female population. Fans identifying with their favorite stars transformed themselves into virtual clones: imitation Jean Harlows, Marlene Dietrichs, Greta Garbos, Barbara Stanwycks, Myrna Loys. The celebrity of Veronica Lake, noted mainly for her long platinum-blond bob falling over one eye, forced factories to require their female workers to wear scarves. Parisian couture, the preserve of a tiny social elite, had little impact on this mass phenomena. Except for the vague imitations worked up by Hollywood costume designers for super-productions. Louise Brooks, with her boyish "bob" haircut and lithe figure, remains one of the most memorable icons of the silent-film era. Just as Rita Hayworth in her long black-satin sheath lives on in our imaginations. Gilda the unforgettable. However, none of the famous vamps caused an earthquake equal to the "Garbo effect." Born Greta Gustafson, this magnetic and enigmatic Swedish woman—a sphinx without a riddle—did for the silver screen what Chanel did for haute couture. She started a revolution.

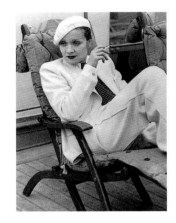

Marlene Dietrich dressed in men's clothing, during a transatlantic cruise, 1932.

Greta Garbo was born in Stockholm, Sweden, in 1905. Known as "The Goddess," she had a pure eye, simple attitude, and understated acting style which, when combined with her life and her myth, effected a decisive transformation on the way feminine allure was perceived. She immediately—while appearing completely natural—created a distance between herself and others that was impossible to cross. Fascinating rather than desirable, she exerted the paralyzing power of Medusa. She was the harbinger of a totally new woman. Garbo—androgynous, ambiguous, and doubly disturbing because she shunned the classic artifices of femininity.

Her films are memorable. As these low-key works unfold, they draw their power from the voice, presence, and illuminated face of Garbo the Divine. Although never consciously seeking to do so, her imperious style and steely self-control led millions of women to identify with the "Garbo Look." These women were responsible for the huge popularity of Garbo's high-boned angular face, hollow

cheeks, thick eyebrows, unkempt hair, pallor and of those mysterious silences that proved more effective than all the little tricks practiced by thousands of vamps with identical peroxide-blond hair. Garbo never aged. A timeless figured remote from the vagaries of fashion, she is still a point of reference today.

"I want to be alone." This famous line from *Grand Hotel*, 1932, is as fresh as ever. The Goddess wishes to be alone. As in real life, she was most expressive when silent. There was only one possible rival to this remarkable introversion, and that was its exact opposite: Marlene Dietrich. This inseparable pair of "fabulous faces" embodied the two extremes of iconic feminine allure as developed during the period between the two World Wars.

Marie Magdalene Von Losch, born in Berlin in 1901, burst upon the public in 1930 in Josef Von Sternberg's immortal film *The Blue Angel*. Dietrich was as extraverted, luminous, and sarcastic as Garbo was secretive, morbid, and gloomy. Garbo met reporters dressed in a dingy trench coat, a man's felt hat tilted over one ear, her eyes hidden behind dark glasses. Dietrich was the quintessential femme fatale, carefully staging each public appearance for maximum impact. Lili Marlene mobilized an entire arsenal of incendiary arts, inflaming every man who crossed her path. Both exploited the androgynous mode, but Greta was wraithlike while Marlene played the tough guy. Six films with Sternberg raised this mythical, consummate vamp to the zenith of her fame. As an anti-Nazi German, her wartime performances for American G.I.s provided fresh opportunities to show off her remarkable physical stamina. Troops on both sides of the conflict instantly adopted the refrain popularized in two languages by her sensual and all-embracing voice: "For you, Lili Marlene." This star of stage and screen sang her life out as much as she lived it, from the ballad of the sad cafés to more glamorous numbers. At the age of 70, Dietrich was still appearing on stage as sublime and indestructible as ever. Only old age, only the passage of time, could diminish her invincibility.

New York as seen by artist Ruben Toledo.

Paul Poiret, inventor of the modern female figure, was right when he claimed our contemporaries are afraid to wear clothes that have not already received public approbation. And yet, although allure owes its uniqueness to its autonomy, it is this very uniqueness that strikes a chord with the mass public. From this point of view, and under infinitely more dramatic circumstances, the Parisian women who maintained their indomitable style under the German Occupation demonstrated considerable courage. Feminine allure upheld, for five long years and in the face of persecution and restrictions, a perhaps frivolous but nonetheless highly visible stratagem for resisting the hardships of the time.

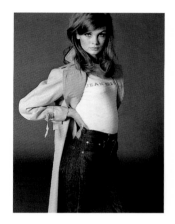

Fashion model Jean Shrimpton in the 1970s.

It was inevitable that when a "New Look" emerged after the Liberation, it would be based on Paris's sense of style and pool of luxury skills and crafts. And a return to the opulent, spoiled "womanly" woman. In the aftermath of wartime suffering, the New Look was a symbol of fresh abundance and peace restored. The bourgeoisie was once again given a flattering mirror before which it could preen. Although Europe was painfully arising from the ruins of war, the model it offered was ultra-glamorous and feminine, decked out in the sophistication and style of the past, persuading the Americas that the ancient continent still reigned supreme in the realm of appearances. Paris had not burned. It glittered and sparkled anew with haute-couture fashion shows and society balls of unprecedented brilliance. A frenetic desire to forget, and the image of unfading womanhood, made it easy to believe that, in 1947, nothing had changed in the best of all possible worlds. Ten years later, however, everything had indeed changed. In much the same way as the outbreak of the First World War had also retarded by a decade the revolutions in feminine style begun in 1907. True liberation came long after the end of the second worldwide conflict, with the Swinging Sixties, the emergence of ready-to-wear, and the development of mass-market women's magazines that were more youthful and sophisticated. A confluence of trends that transformed our daily lives.

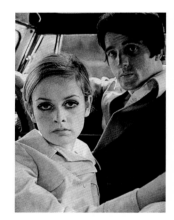

Twiggy, iconic model of the 1960s, posing for the cover of *London Life*.

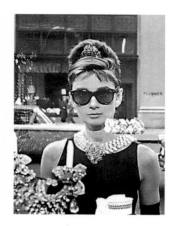

Audrey Hepburn, her wardrobe designed by Hubert de Givenchy, in Blake Edwards's film *Breakfast at Tiffany's*, 1961.

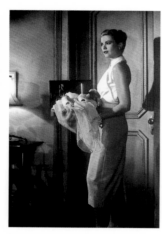

Grace Kelly in Alfred Hitchcock's film *Rear Window*, 1954.

Elegance, new fashions, change, beauty, health-care, hygiene, and even dignity—all the components of allure—were readily accessible to a greater number of women. Their models were no longer remote sovereigns residing in the empyrean of elegance, but ordinary women—only a little bit more so—who took over the covers of mass-circulation magazines. Today style is set in the street. The rich and famous are welcome to perpetuate the rituals that are theirs and theirs alone. Very charming, no doubt, but less and less relevant to the rest of us. Farewell soft dreamy eyes, languid poses, plump cheeks, rosebud lips, eyebrows arched in feigned naiveté, tiny feet taking tiny steps on the thick carpeting of luxury hotels. Running shoes are in.

In 1960, cleavage became less important than svelte, boyish hips. Shoulders showed off their bones. Full-blown beauty, only yesterday considered the epitome of the womanly woman, is out. "Blondes à croquer" (baby-doll blonds) was the first blockbuster slogan invented by Marcel Bleustein-Blanchet, founder of the Publicis ad agency. But those baby dolls were just junk food marketed to the public by images of healthy, radiant girls—living dolls. But feminism, and its war against the disposable Kleenex woman, was right around the corner. Along with those women who sent their bras flying at the merry month of May 1968 demonstrations in Paris and Washington D.C.

The feminine feature that perhaps changed most, more than any other part of the body, is the hands. Thirty years ago, women's hands were admired for being small and dimpled, with tapered fingers. Today, raw knuckles are showing their stuff, meaner and tougher, like the little wooden hammers that strike notes on a piano. When a woman holds her handbag today, she grips it with her thumb. Thirty years ago, "the thumb was supposed to remain unseen, it was discreetly hidden, the bag held lightly in the fingertips, the little finger raised" (*The Glass of Fashion*, by Cecil Beaton, Doubleday, 1954).

The radical changes in the feminine form begun in the 1920s continue today through exercise and diet, which have irreversibly transformed the overall allure of the feminine population. An eloquent example and one of the most enduring—still evoked by the manufacturers of luxury goods today—is Audrey Hepburn. In the late 1950s and early 1960s, following the triumph of her Oscar-winning film *Sabrina* and the no less memorable *Breakfast at Tiffany's*, this sylph represented a stunning exercise in style. She combined the reserve of a slender, proper, eternal debutante with the glamorous allure of a top model for couturier Hubert de Givenchy. When he designed Audrey's hallmark black sheath, pumps, gloves, and equally dark glasses, Givenchy created one of the most exemplary and justly famed silhouettes in the entire history of 20th century allure. Grace Kelly, the blond version of these trim "Made in the USA" girls, as impeccable wearing jeans as white gloves, became a real princess, ruling over a microcosmic empire perched on a rock. She and Audrey Hepburn, both fated to disappear prematurely, represented the final generation of these birds of paradise, the most famous literary example of which remains the Duchesse de Guermantes, so meticulously observed by Marcel Proust.

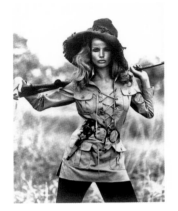

Fashion model Verushka in 1968, wearing a safari jacket by Yves Saint Laurent.

The social upheavals of the 1970s, the fashion for anti-fashion, and the profound evolution in appearances did not abolish the distinction that sets a few exceptional women apart. But allure in its new guise was nevertheless to be crucially affected by two interrelated phenomena. First, an emphasis on the human body unprecedented since the time of ancient Greece: the body exposed, exalted, in action, dreamt of but unattainable due to the eternal perfection implied by eternal youth. Human nature, caught on film in the green pastures of the consumer society, evokes a paradise that now haunts the collective unconscious. A heavenly host of breasts and beatification. An egocentric religion in which the "me" exists only in the eyes of "the other."

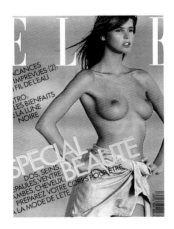

Top-model Elle McPherson on the cover of French *Elle*, May 1987.

Famed fashion editor
Diana Vreeland in 1942.

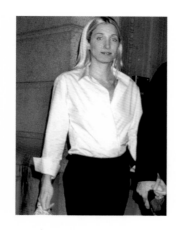

Carolyn Bessette-Kennedy,
1998.

And, second, a corollary phenomenon: the gradual emergence during the 20th century's final two decades of the "top model." A kind of two-dimensional star system, immortalizing on glossy paper the images of super-mannequins known only by their first names and expected—today more than ever—to be beautiful and keep their mouths shut. Raised to the status of contemporary icons, these heroines, whose swift and apparently easy wealth obsessed the anxious masses of the 1980s, and endowed that glittering era with a surrogate soul. Back when haute couture reigned supreme, we already had a few individuals like the two Hepburns—Audrey and Katharine—who, through their inimitable chic, combined a talent for wearing clothes with the art of posing in front of a camera. Even earlier examples that perhaps cast a retrospective light on the "top-model" phenomenon are the muses who inspired great painters in the past, such as Raphael's *La Fornarina* and the elusive *Mona Lisa*. Never before our own time, however, has the image of so few been imposed on so many, so absolutely. Projecting its added value with formidable effectiveness onto products of mind-boggling diversity: cars, T-shirts, luxury cosmetics—and even Wall Street IPOs.

Women of the 80s—both image-makers and prisoners of the camera lens, but more liberated than ever before; flesh and blood creatures, who without claiming equality with men succeed in achieving explicit superiority over them in terms of income, fame and influence on the anonymous crowd. It's irritating. These girls, these women, are the subtle and varied expressions of time—time passing, time leaving us behind. In the last analysis, all that counts are these mirrors reflecting women's image and sending it back to them.

The allure of women—or of girls, today—is now expressed in multiple ways and according to rules that are much less rigid than in the past. The "Best Dressed"

list was an outgrowth of the great couture houses and their clientele, a vanishing breed today. Meanwhile, the waistline, the body, the proportions of the figure, the concepts of beauty, are evolving dramatically. Everything is changing: the way women walk, the way they talk.

The signs of distinction that consisted—as the very word distinction implies—in belonging to an exclusive Café Society coterie, an elite of good taste and wealth, of fine clothes and fine manners, have been overturned today by the pressure of the masses. The masses have absorbed the exceptional into the everyday. The influence of the Pop movement—Pop Art, Pop Music, Pop everything—looms large in this shift. "From now on, everyone will have their fifteen minutes of fame," said Andy Warhol, a prediction that is confirmed daily. Warhol himself was instrumental in projecting a touch of his own genius onto the unknowns he transformed into stars. Inspired by film close-ups, new modes of duplication, television, and the desire to accumulate characteristic of a consumer society, his serigraphed icons have become the abstract goddesses of our time. It would have seemed inconceivable, before the 1960s, to duplicate the images of women like Elizabeth Taylor, Marilyn Monroe, or Jacqueline Kennedy using the same techniques as for commonplace posters and ads.

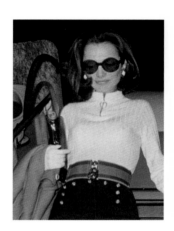

Lee Radziwill arriving in Acapulco, 1967.

Many women who once would have been categorized as striking but not beautiful—along the lines of a Marquise Casati, Diana Vreeland, Elsa Schiaparelli or Chanel—are now considered emblematic of our times. Because of their inherent originality, a shrewd emphasis on physical flaws has become a sign of allure. From this point of view, the Punk movement of the 1980s pioneered a sort of proletarian aristocracy whose subversive attitude a few alert designers—notably the Japanese—were quick to appropriate and have continued to appropriate, inventing a new kind of allure.

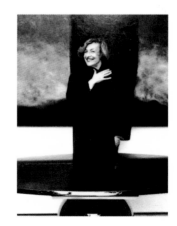

Portrait of Andrée Putman, by Michael Roberts, 1985.

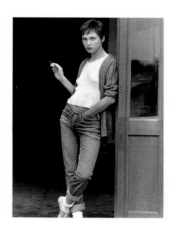

Jane Birkin posing on the set
of Serge Gainsbourg's film,
Je t'aime moi non plus, 1975.

The survival of the fittest—on speed. In the past, allure was, for many women,
a secret weapon for attracting men in situations apparently more enviable
than their own. Today, women care about being chic and looking well for
their own pleasure. From this point of view, the style of Audrey Hepburn,
of Jackie O. and her sister Lee Radziwill, even though still exerting an impact
on current fashion, already belongs to the past. Clearly, the women
who identify with those 60s heroines are now leading radically different
lives themselves.

The "cult of youth" leading cosmetic manufacturers to select sixteen-year-old
girls to promote their anti-wrinkle creams is no guarantee that being underage
and underweight will be enduring criteria for feminine allure. Diana Vreeland,
at the very end of her career, had achieved a degree of fame and prestige,
an attraction, undreamed of when she was twenty. In France, Andrée Putman—
today considered a great lady of style—is very much in the public eye,
playing top-model for Gap and for her own brand of eyewear. She is revered,
imitated, and photographed from New York to Tokyo. She has nothing to fear—
on the contrary!—from youthful Vanessa Paradis and Audrey Marney.
In this liberating context, the recurrent strand of androgyny woven into the
 fabric of 20th century style is assuming new forms.
By adopting male symbols, feminine allure is perhaps in the process of melding
with the masculine in a context of timelessness and genuine indifference to the
duel of opposites. Will we soon be referring to female "dandies?"

In any case, allure will always raze and amaze, be gilded and beguiling, dazing
and dazzling. We bow to its implacability, we sacrifice to the sacred idol.
And will continue to do so, until the day when its imaginative resources cease
to inspire the collective unconscious.
The iconic woman is an exhibitionist, overtly expressing a visceral anxiety

that is secret and deep-seated. No spell is strong enough to overcome the fervor it arouses. It has left a trace, in the photographs illustrating these pages, of moments, of gestures, of an ephemeral enthusiasm that has given fleeting feminine allure its air of immortality.

FRANÇOIS BAUDOT

Post-Scriptum

During the difficult task of selecting illustrations for this book, your author and editor were struck by a recurrent theme running through feminine allure. Many of our models posed holding a lit cigarette. As non-smokers ourselves, and by no means encouraging our readers to smoke, we decided to let the latter analyze for themselves this need felt by certain women to shroud their mystery in curls of smoke swirling around their faces. Halo or phallic symbol, a need to occupy the hands, to express insolence, independence, anxiety? Or just incidental? Someone should write a short history of the cigarette—not as a drug—but as a phallic substitute for a century of allure going up in smoke.

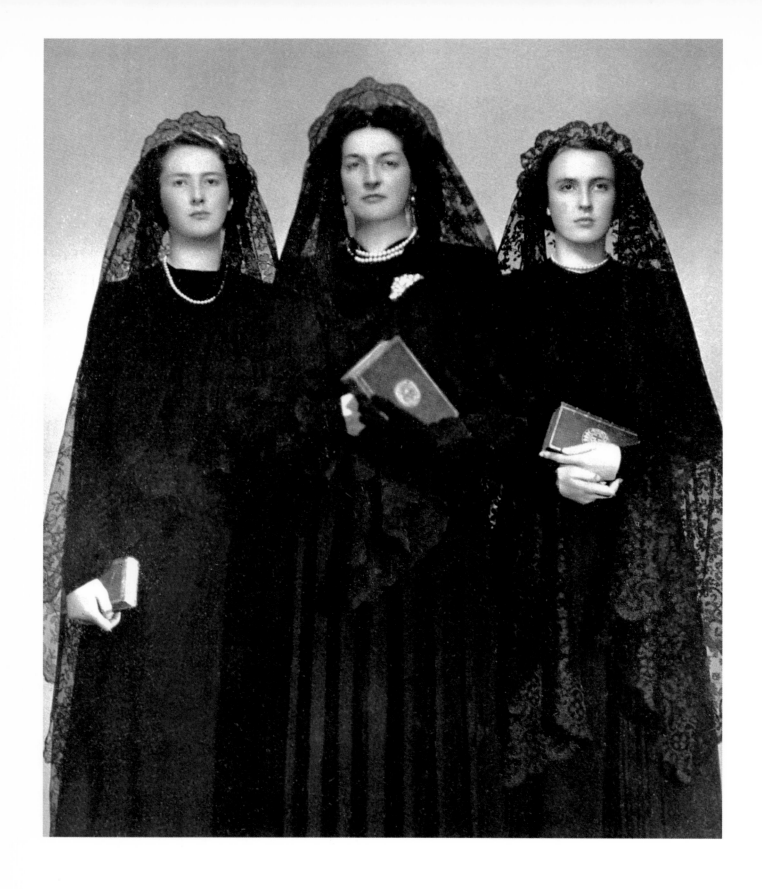

Above:
Sicilian women, 1900.

Opposite:
Donna Marella Agnelli, Princess Caracciolo, at Villefranche-sur-Mer, circa 1965.

Following pages (from left to right):
Film-star and dancer Cyd Charisse, 1965.
Mireille Darc in Georges Lautner's film *The Man with One Black Shoe*.
Black sheath designed especially for the film by Guy Laroche, 1973.
Jane Fonda in Alan J. Pakula's film *Klute*, 1971.
Rita Hayworth in Charles Vidor's film *Gilda*, 1946.

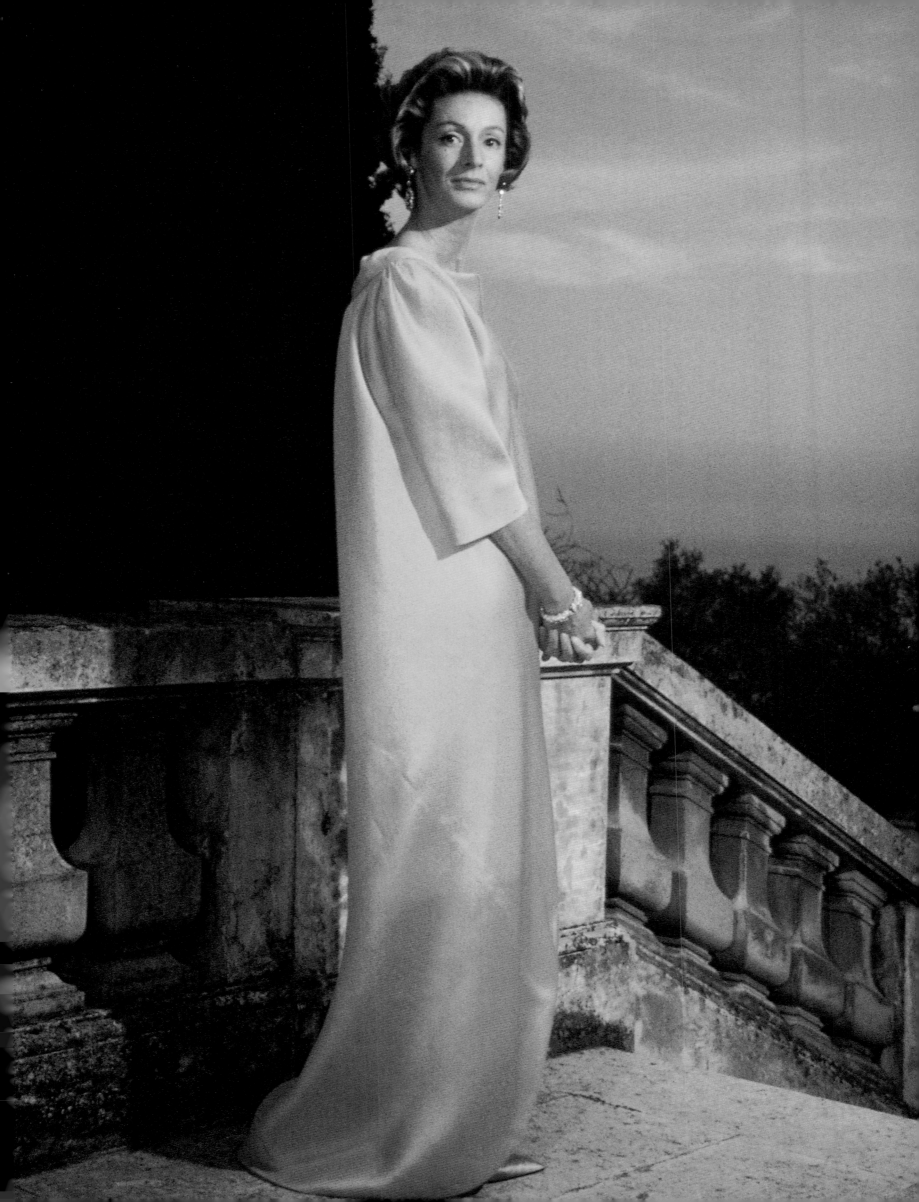

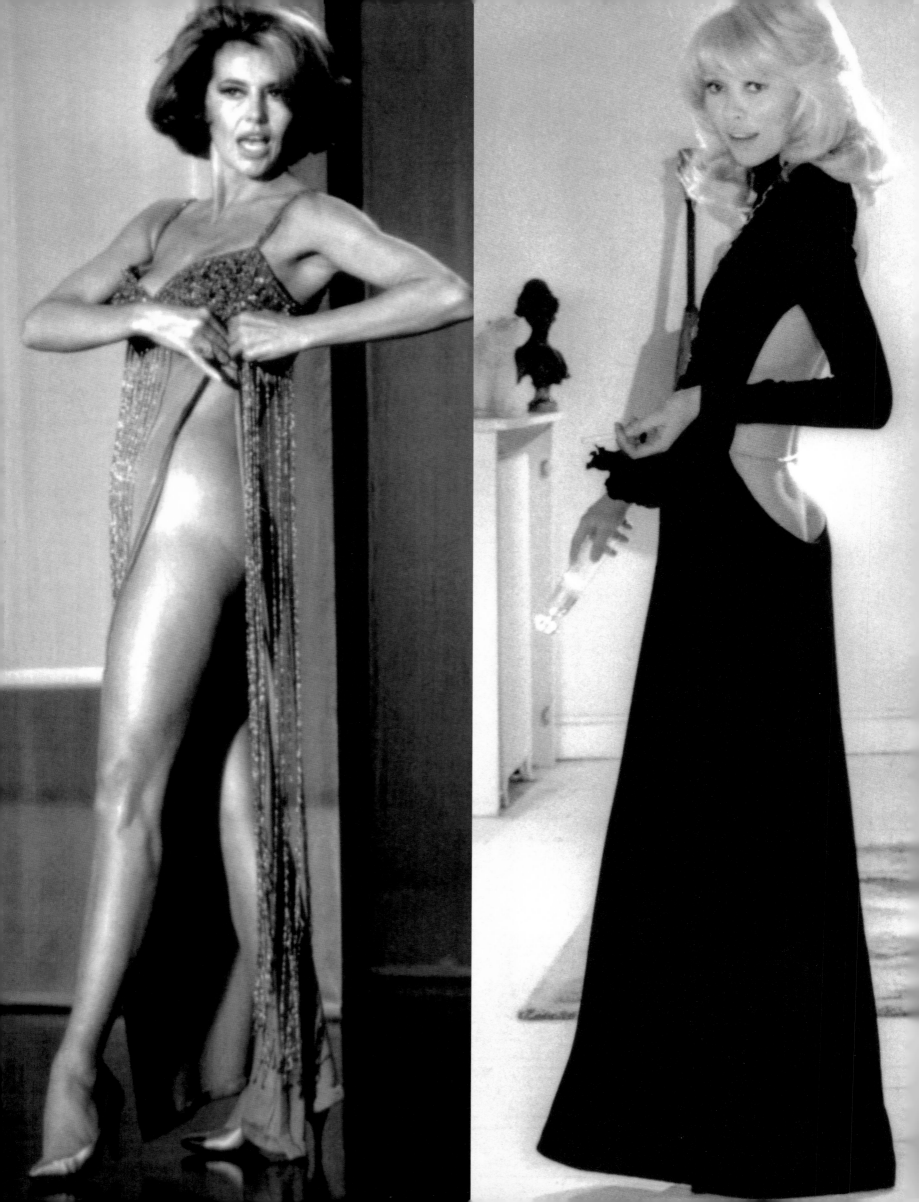

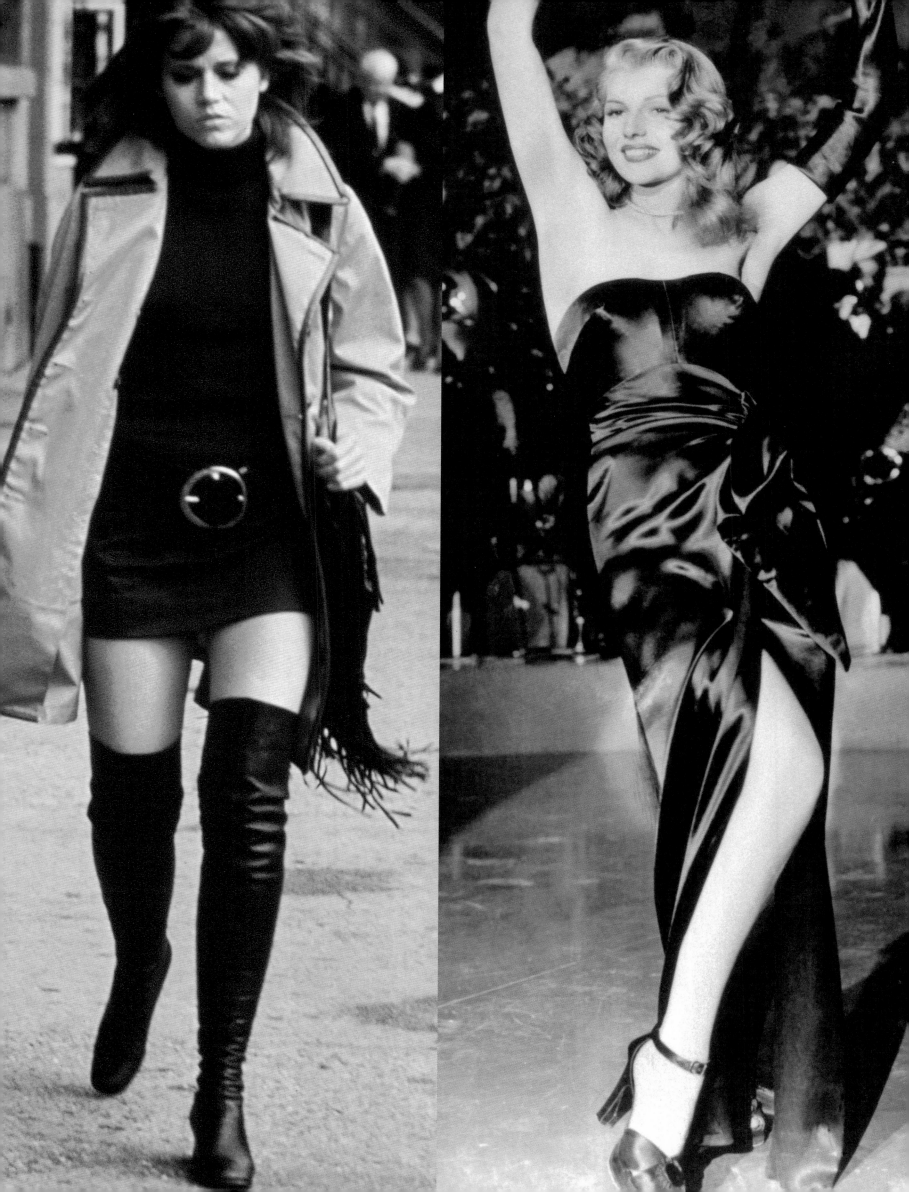

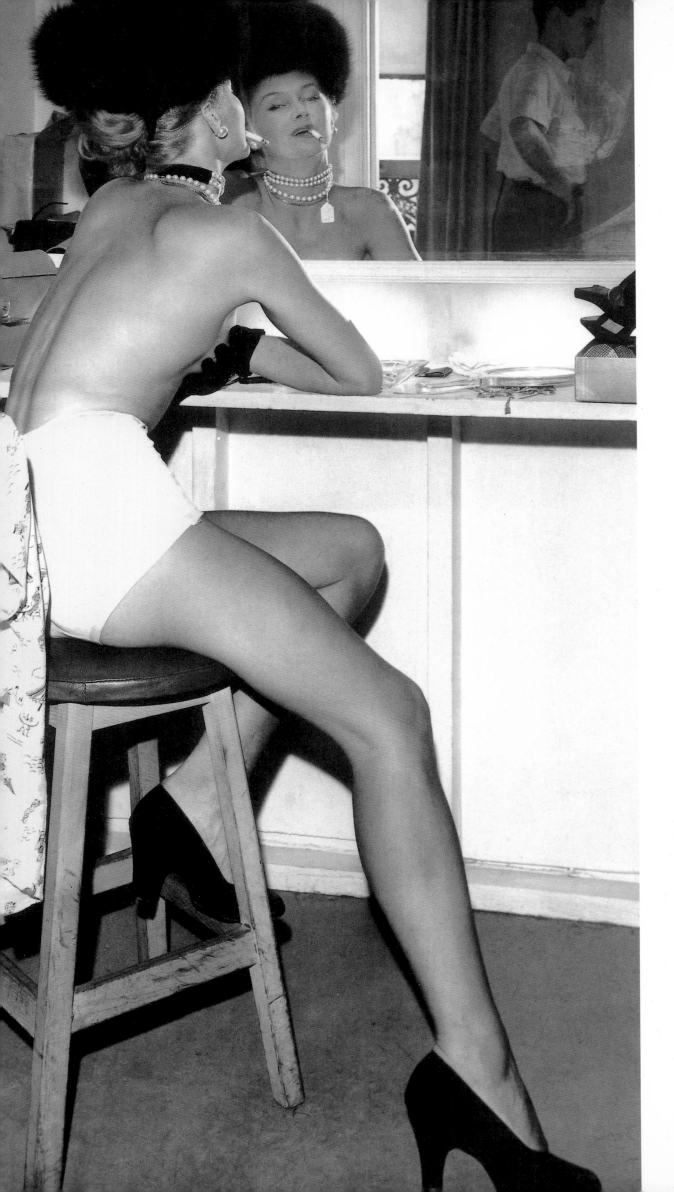

Left:
Fashion model Lisa
Fonssagrives, photographed
in her dressing room by her
husband, 1942.

Right:
Twiggy launches her own
ready-to-wear collection in
the United States, 1967.

Following pages:
Portrait of Anouk Aimée,
by William Klein, 1961.

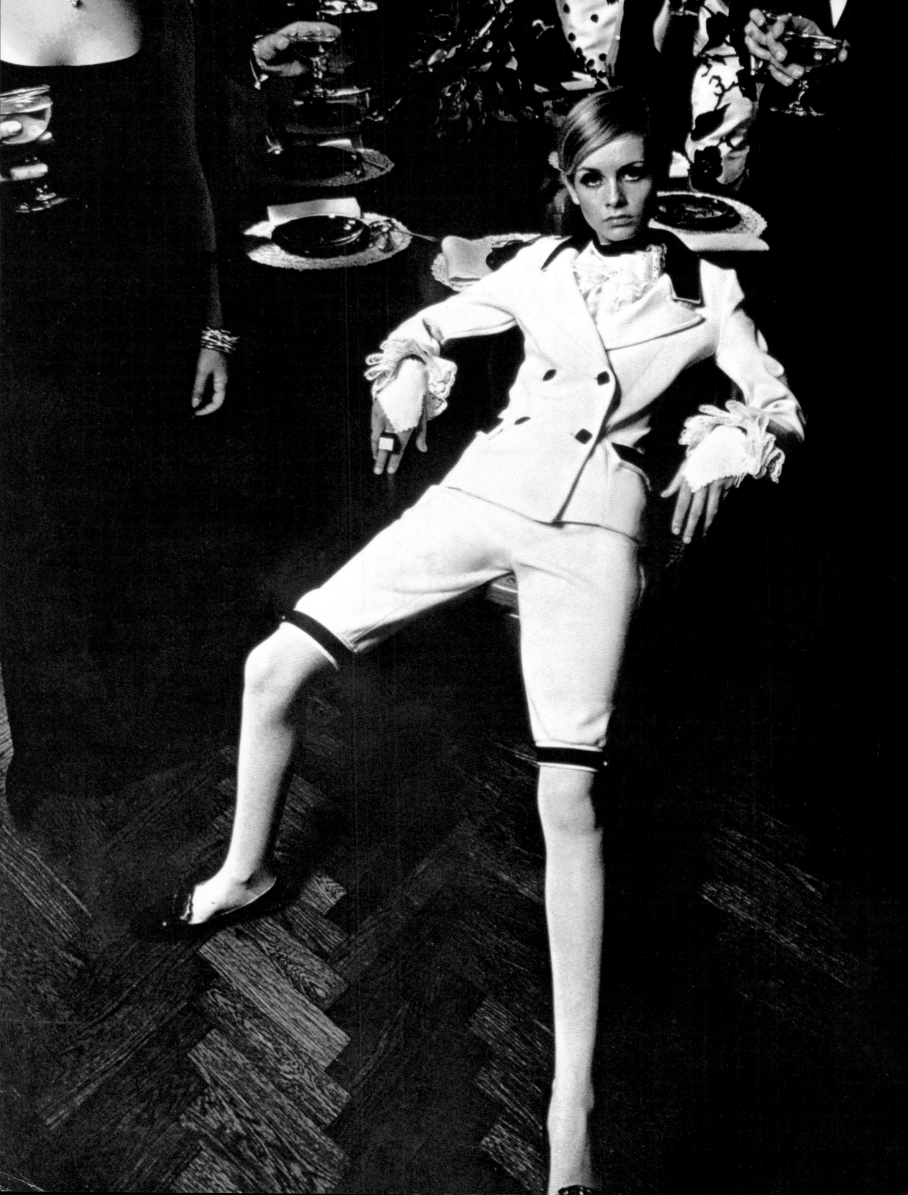

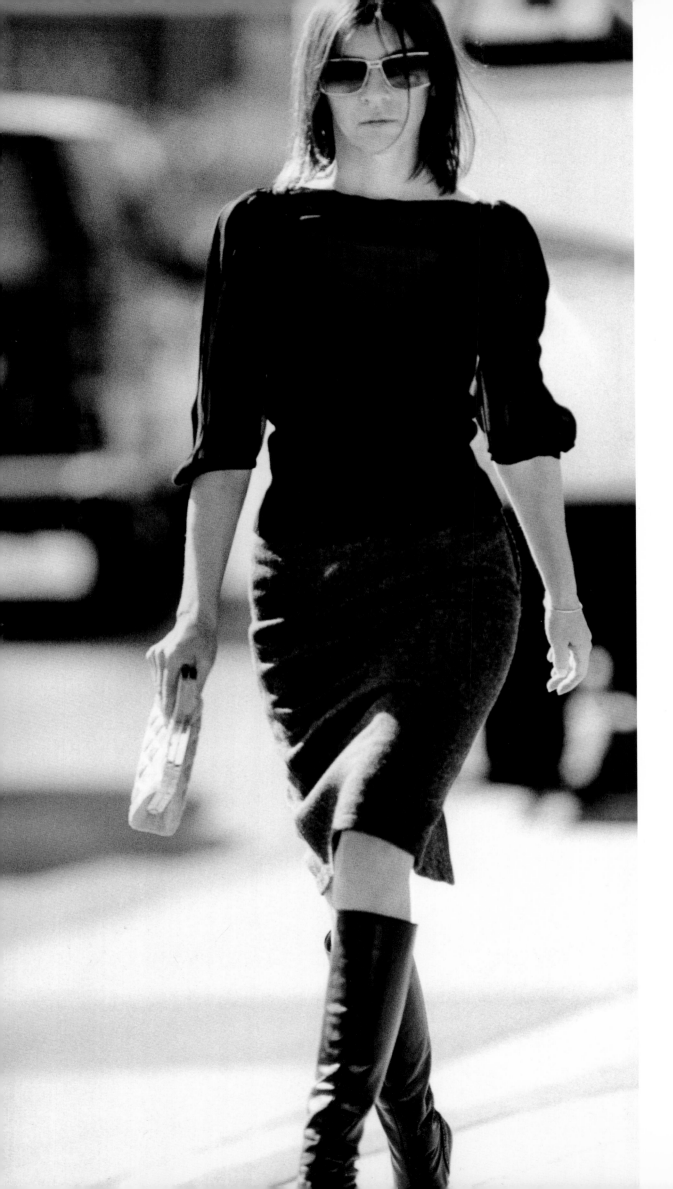

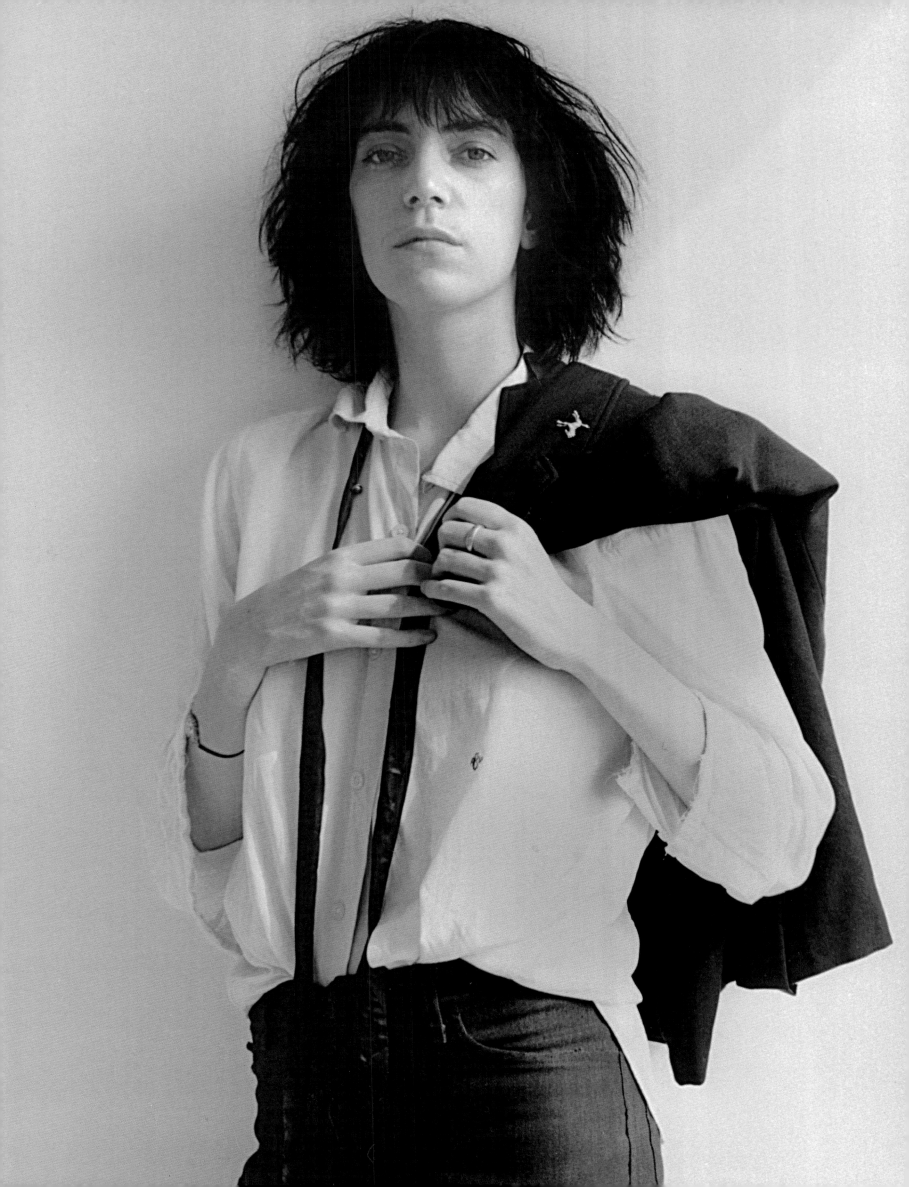

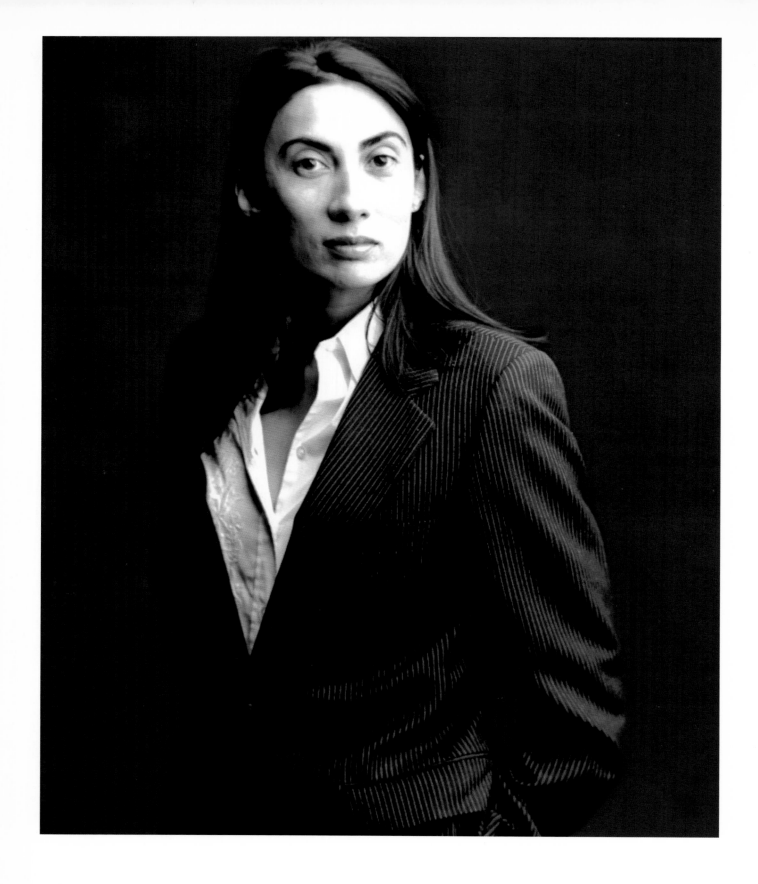

Above:
Portrait of Anh Duong, by Timothy Greenfield-Sanders, 2000.

Opposite:
Demolished, surrealist self-portrait by Frida Kahlo, 1944.

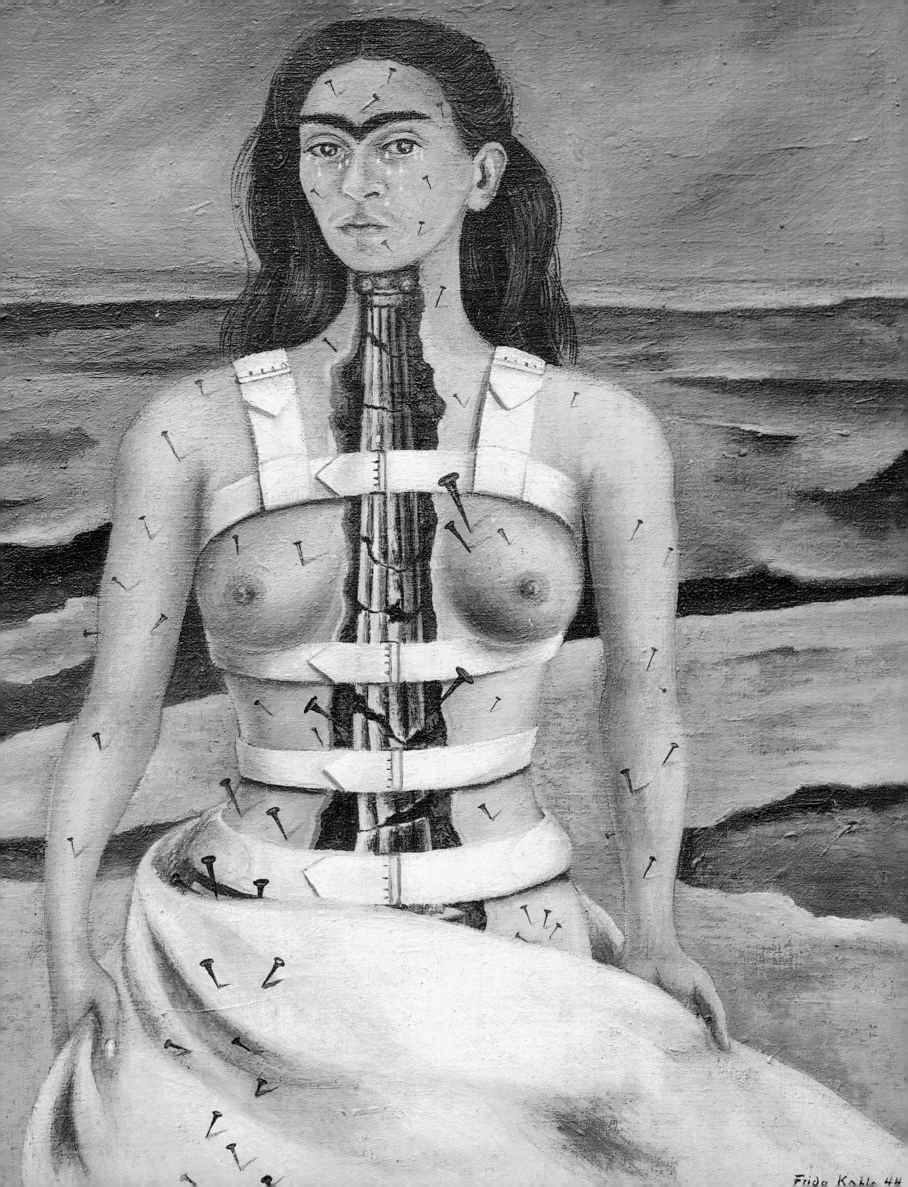

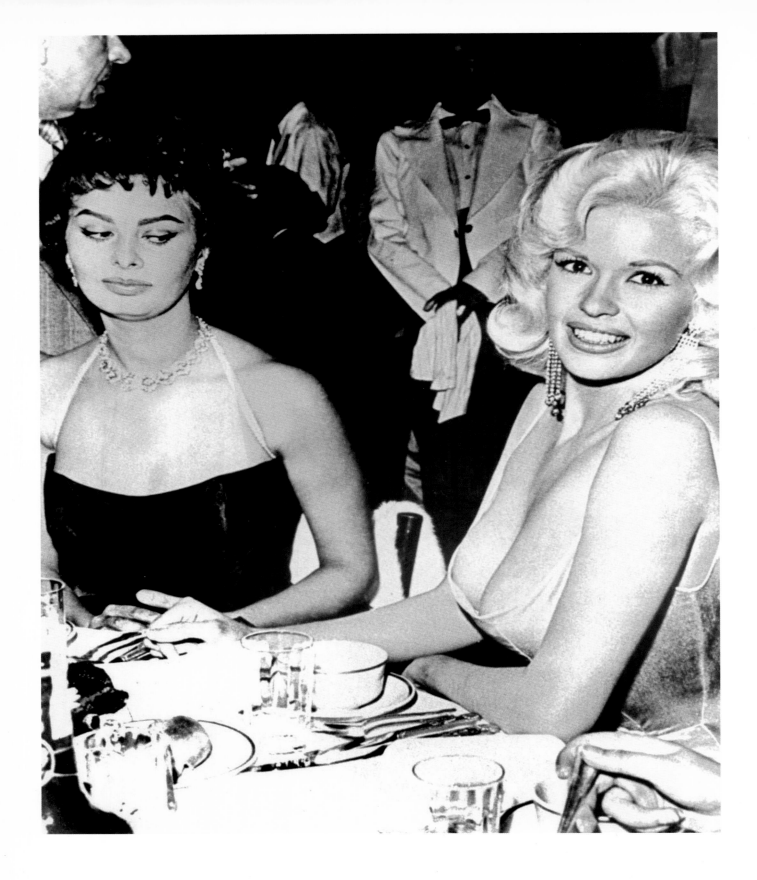

Above:
Sophia Loren and Jayne Mansfield dining
at Romanoff's in 1957, by Joe Shere.

Opposite:
Maria Felix posing for Roger Corbeau on the set
of Yves Ciampi's film *Les héros sont fatigués*, 1955.

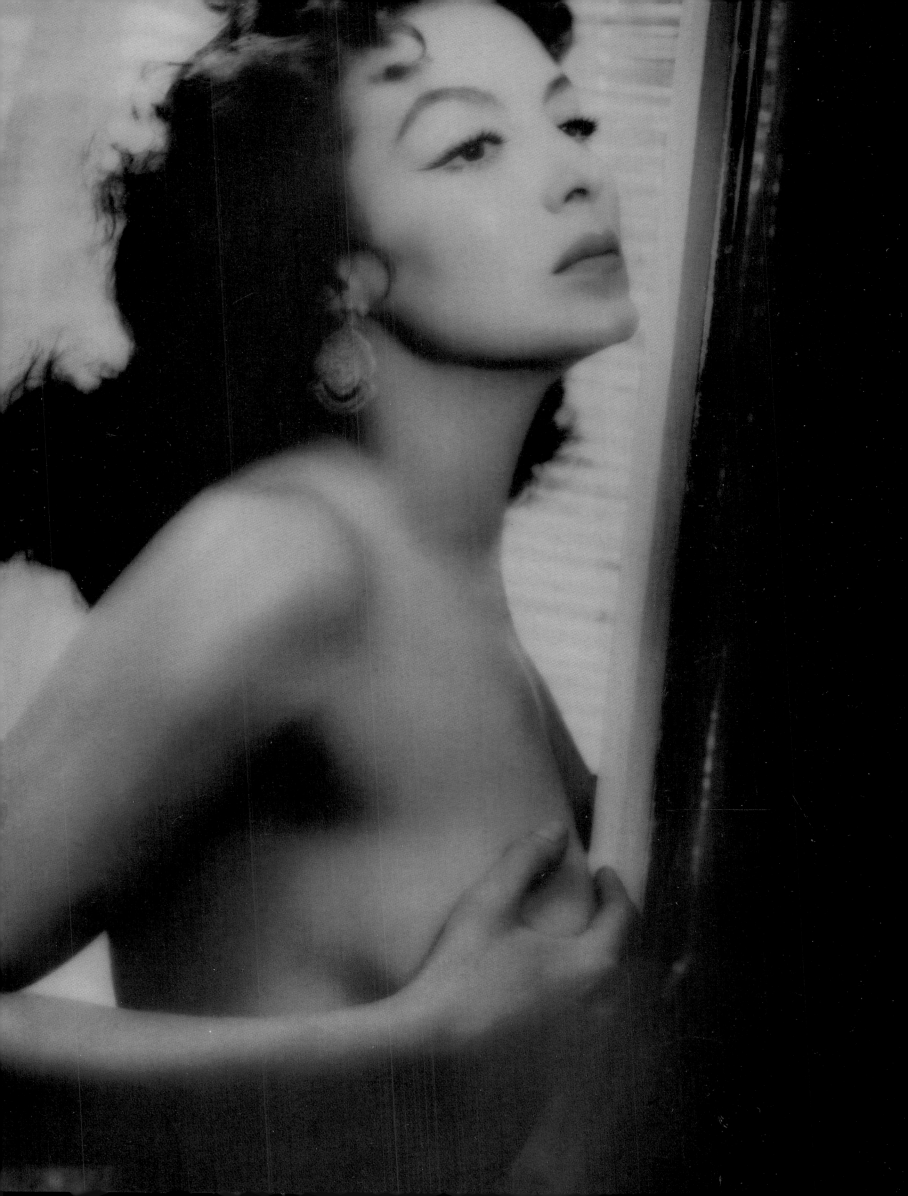

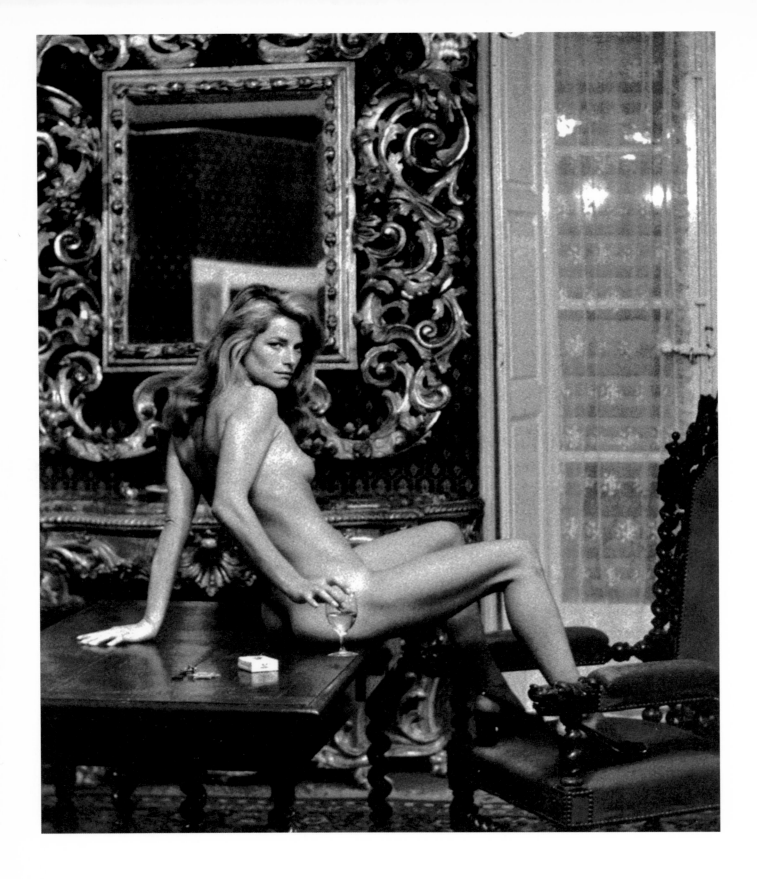

Above:
Charlotte Rampling, photographed by Helmut Newton
at the Hôtel Nord Pinus in Arles, 1973.

Opposite:
Katharine Hepburn.

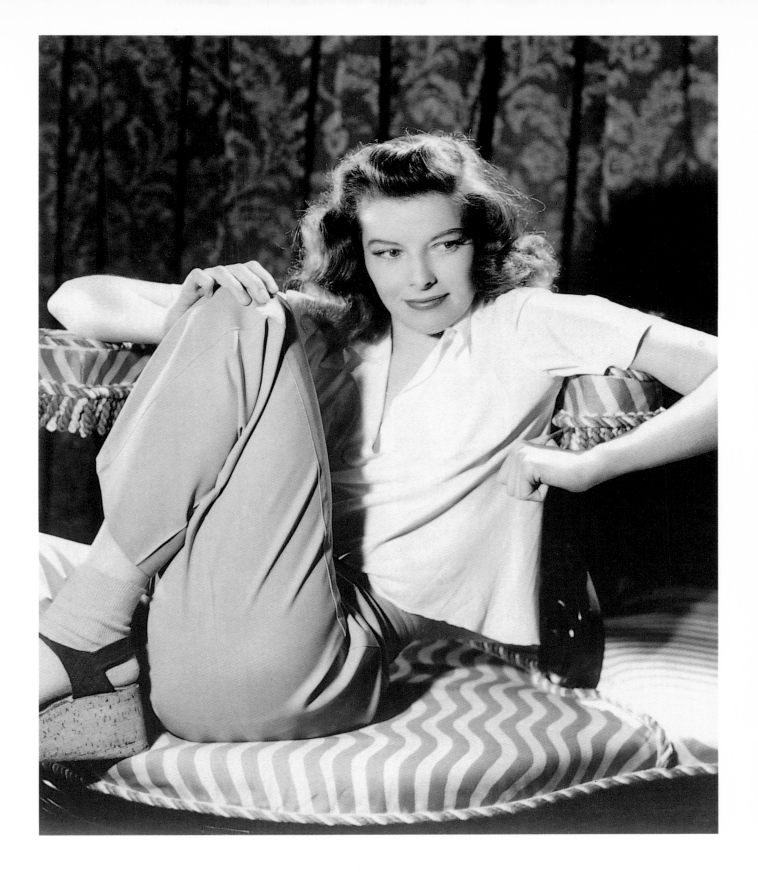

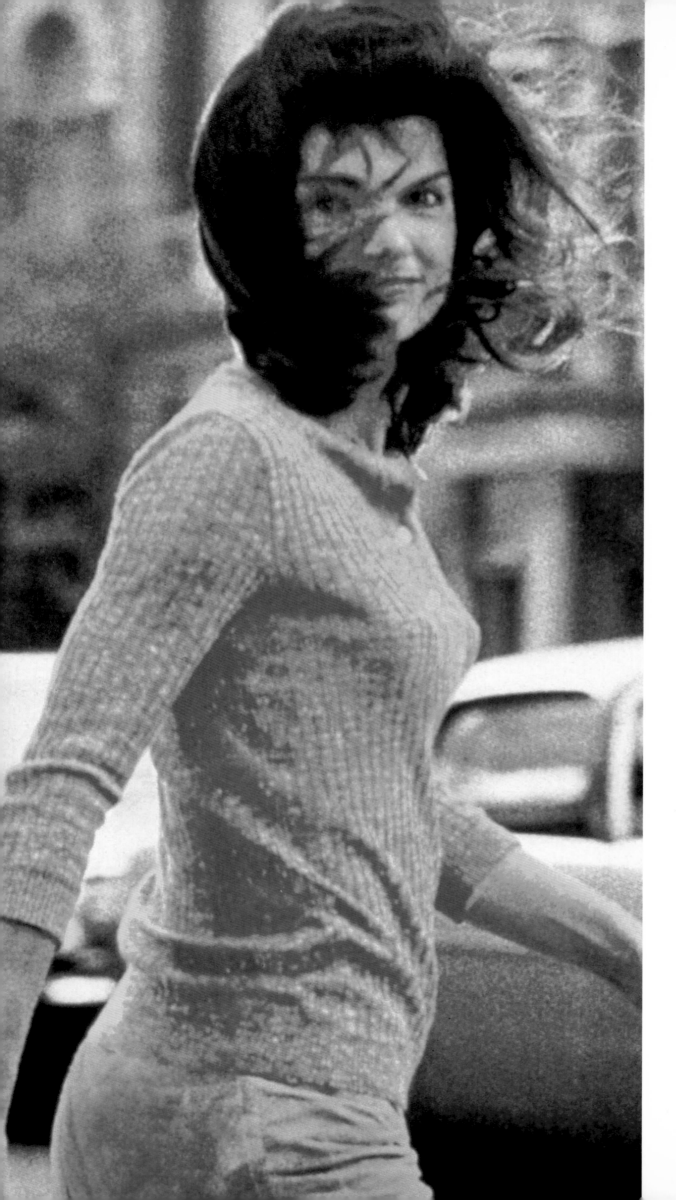

Jacqueline Kennedy-Onassis
leaving her New York
apartment, October 1971.
Photo by paparazzo
Ron Galella.

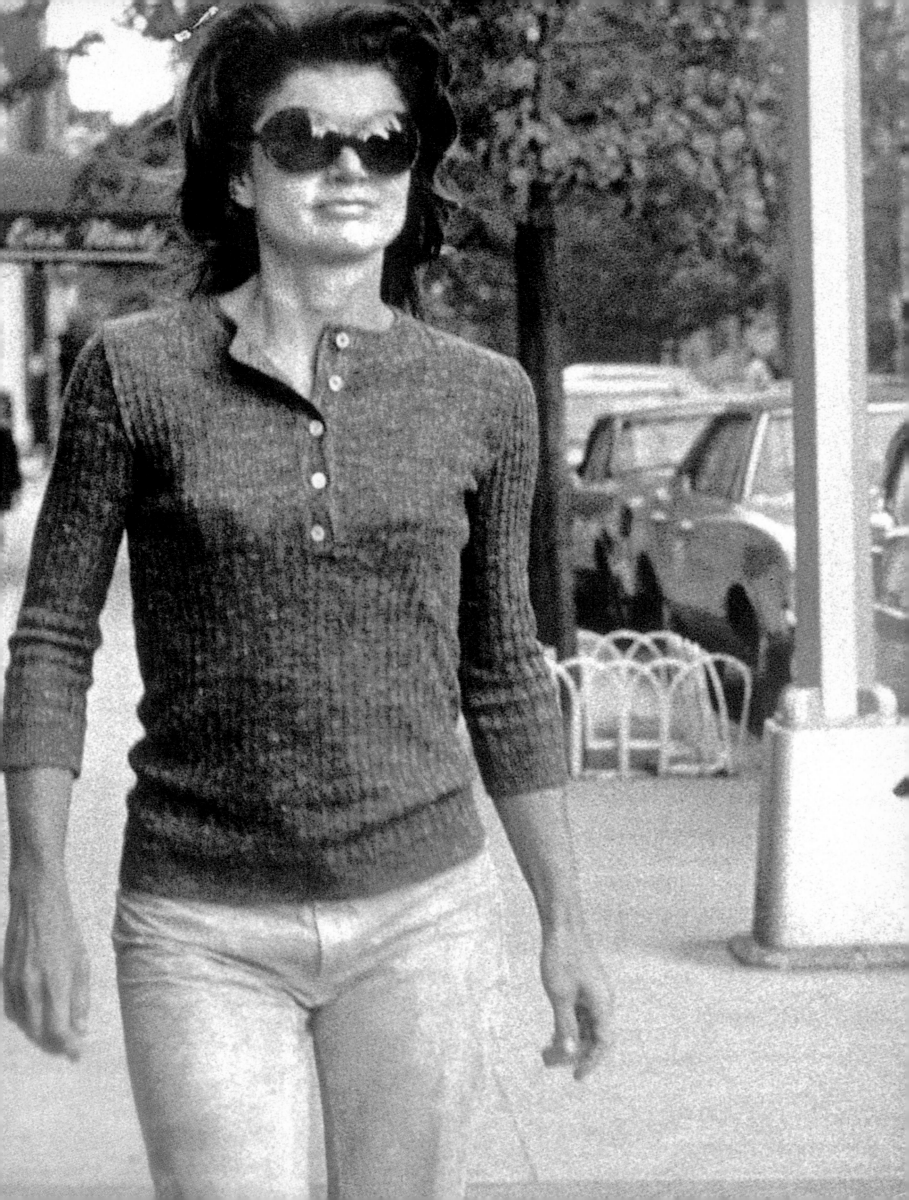

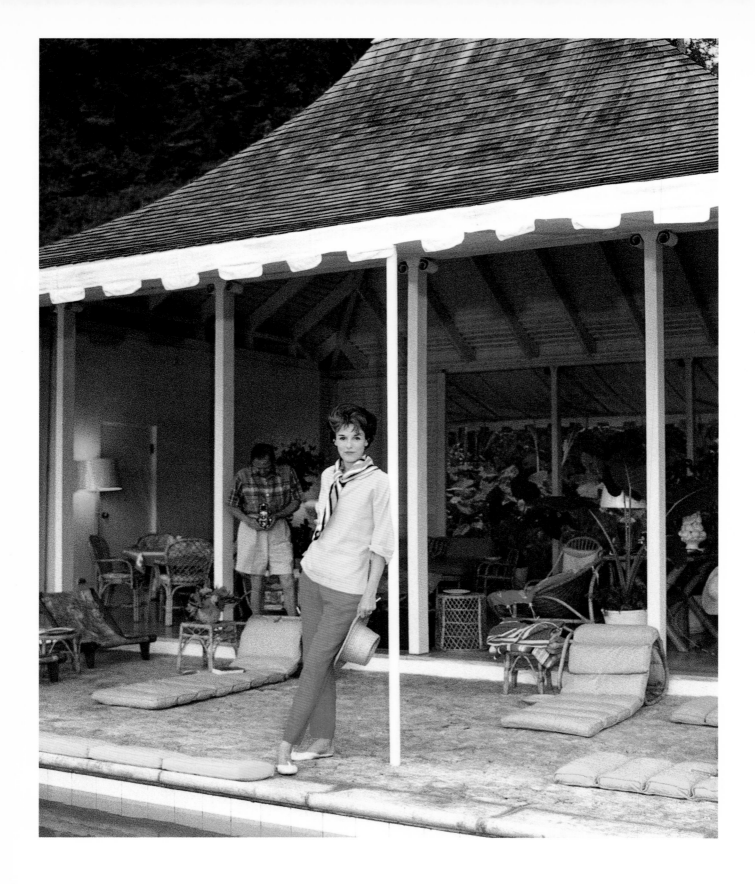

Above:
"Babe" (Mrs. William) Paley in her cottage at Round Hill.

Opposite:
The Honorable Mrs. Reginald Fellows standing in front of a Veronese fresco as she prepares
to make her entrance at Venice's Bestegui Ball, photographed by Cecil Beaton, 1951.

Following pages:
"La Belle Renée," photographed by Jacques-Henri Lartigue
on the road from Paris to Aix-les-Bains, July 1931.

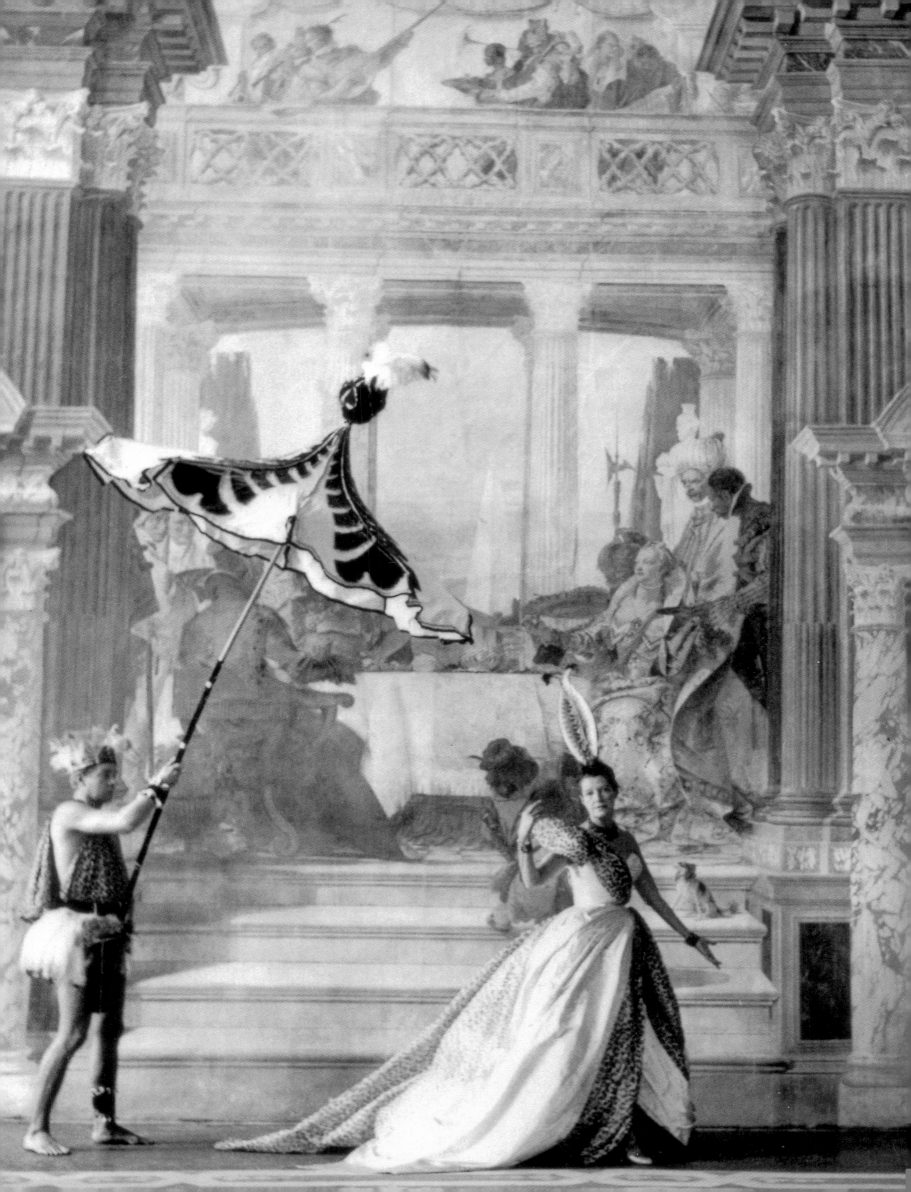

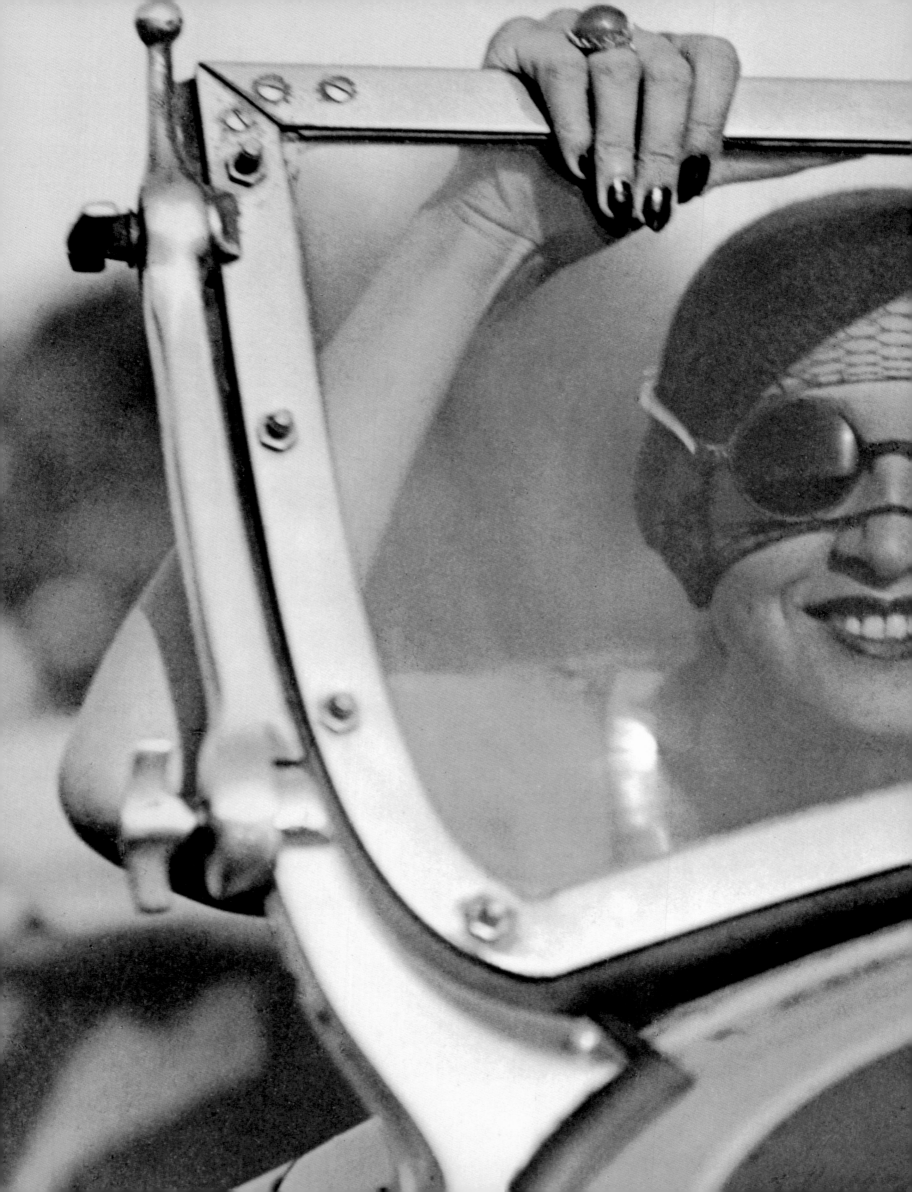

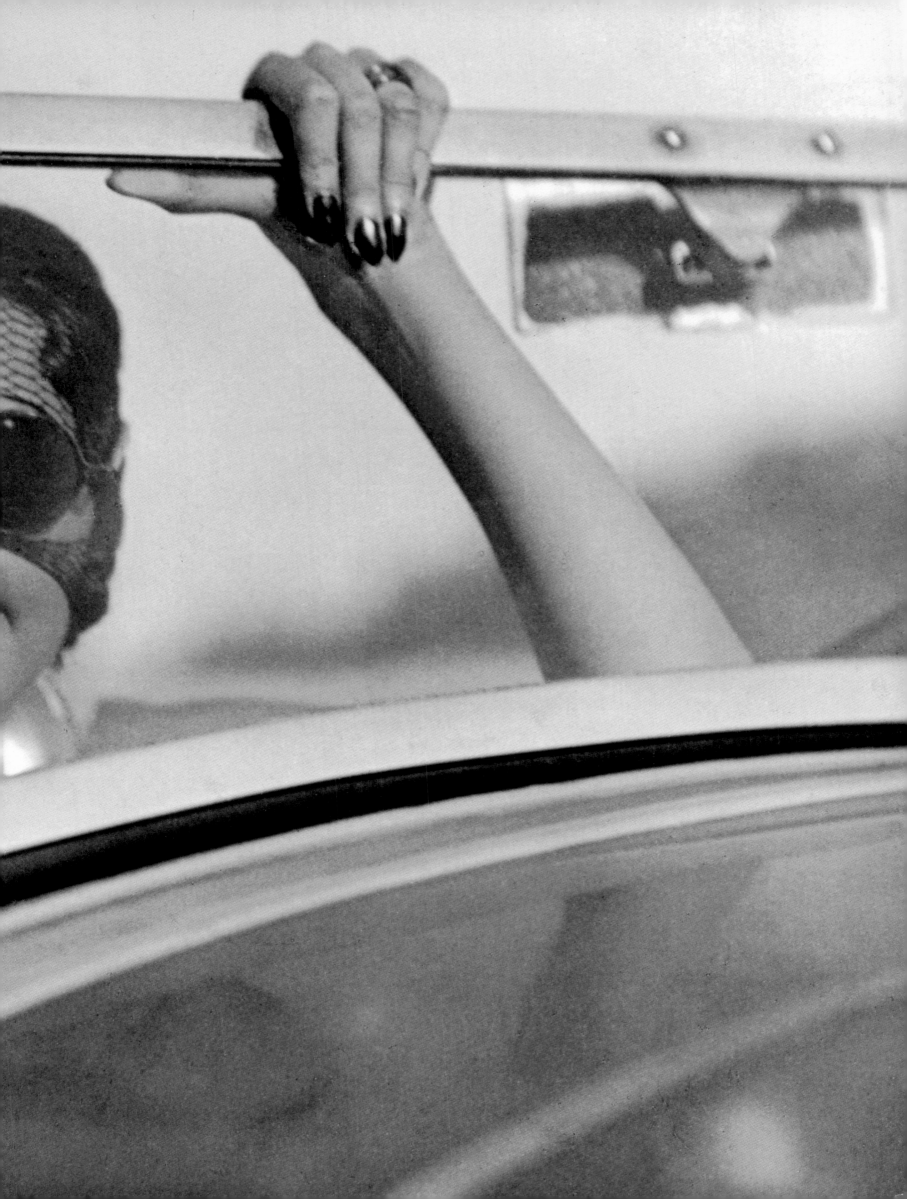

Above:
Paloma Picasso at Saint-Tropez, by Helmut Newton, 1973.

Opposite:
Yves Saint Laurent's guardian angel Loulou de la Falaise,
photographed by Jean-Pierre Maclet, 1980.

Pedro Almodovar's favorite
film star, Rossy de Palma,
by Alberto Garcia Alix, 1987.

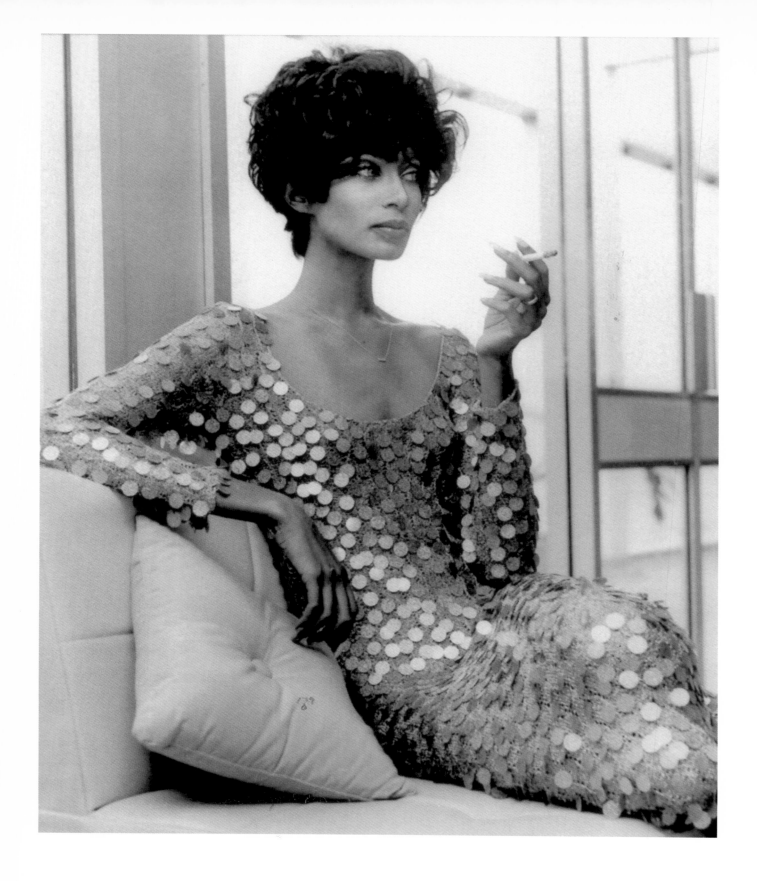

Above:
Film star and fashion model Donyale Luna, 1967.

Opposite:
Fashion model Stella Tennant, 1997, by Stephen Danelian.

Following pages:
Romy Schneider as "Pupe" in the sketch "Il lavoro"
by Luchino Visconti in the film *Boccaccio 70*, 1962.

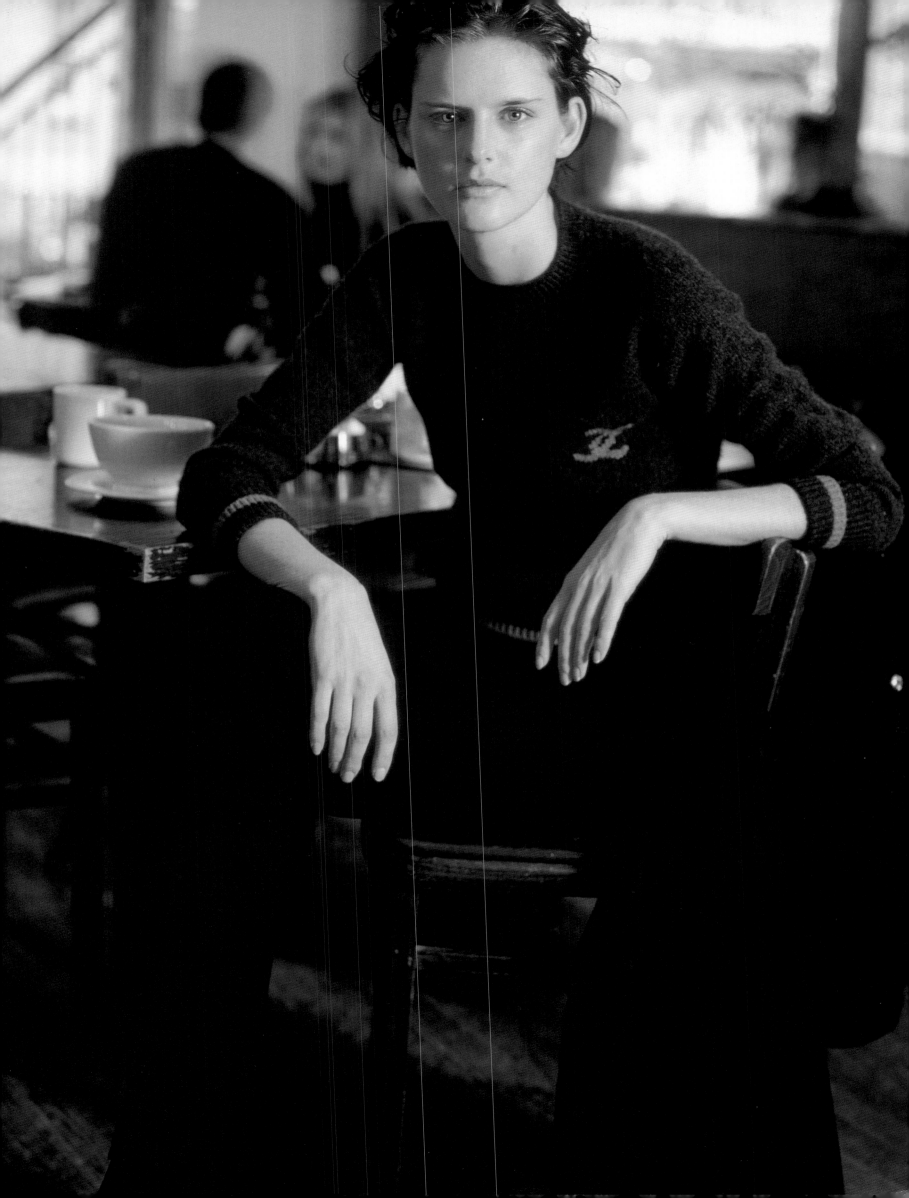

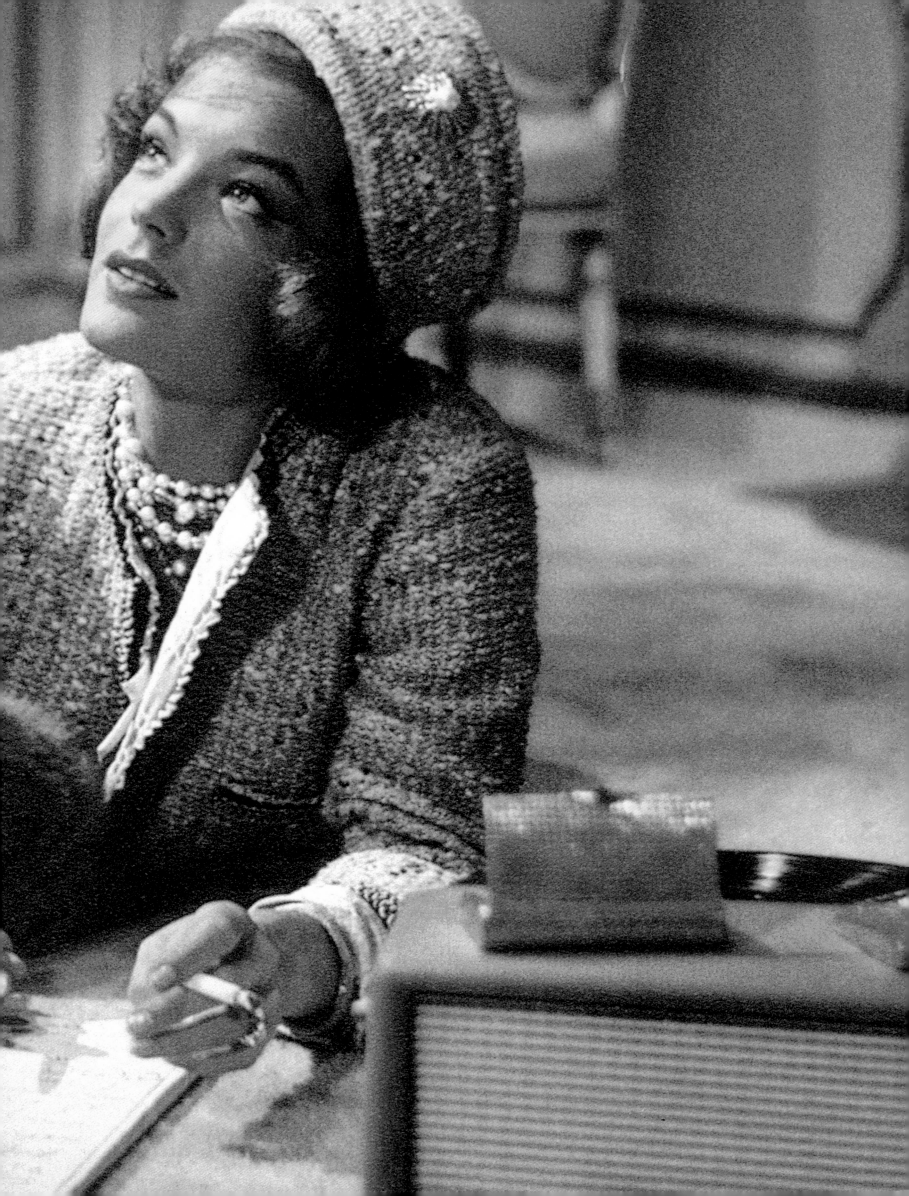

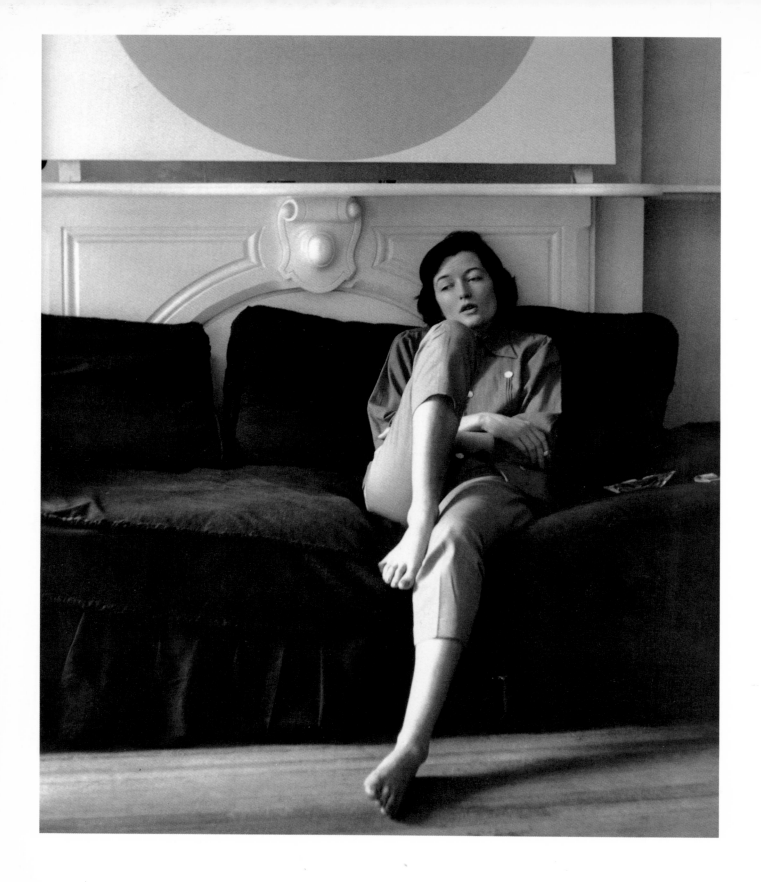

Left:
Artist and model Maxime, Comtesse de la Falaise, photographed by Alexander Lieberman, 1953.

Right:
Anne Bancroft and Dustin Hoffman in Mike Nichols's film *The Graduate*, 1967.

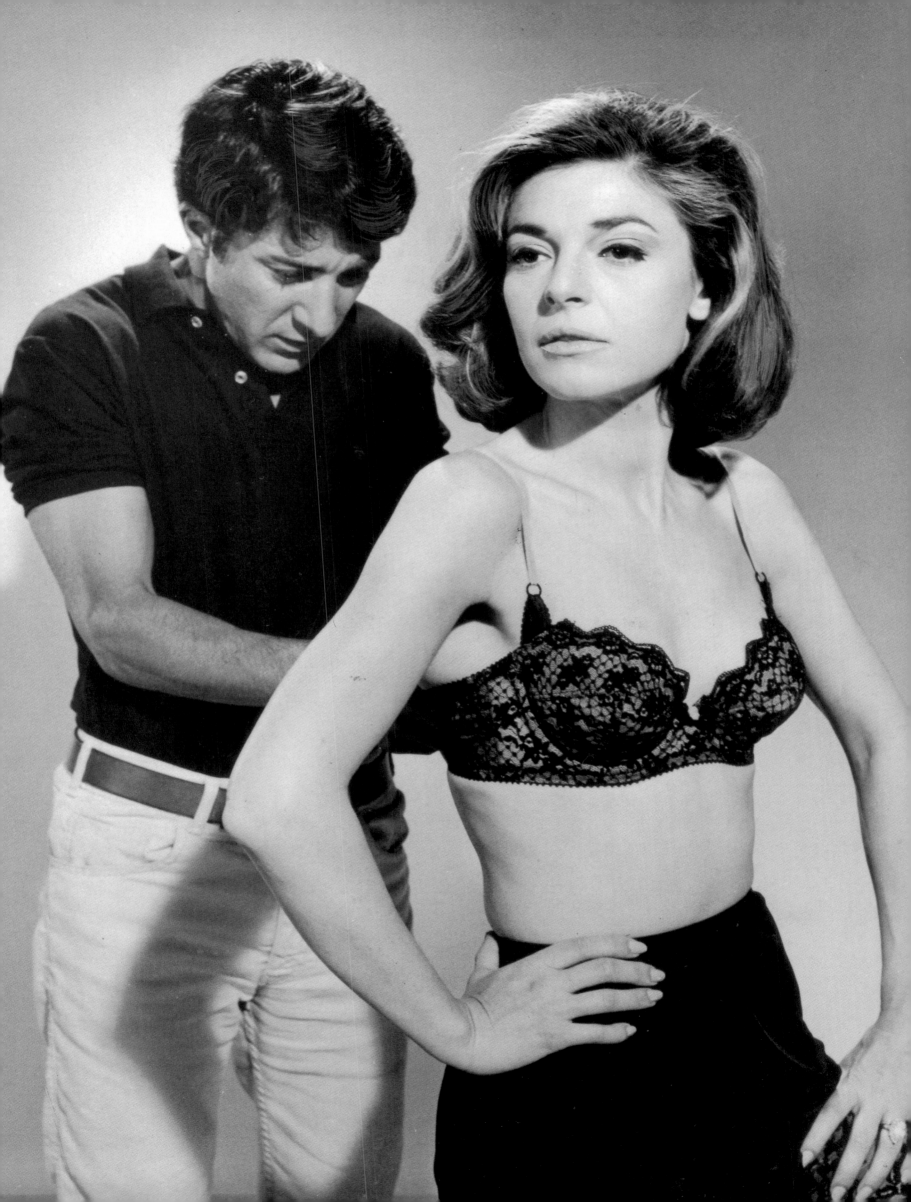

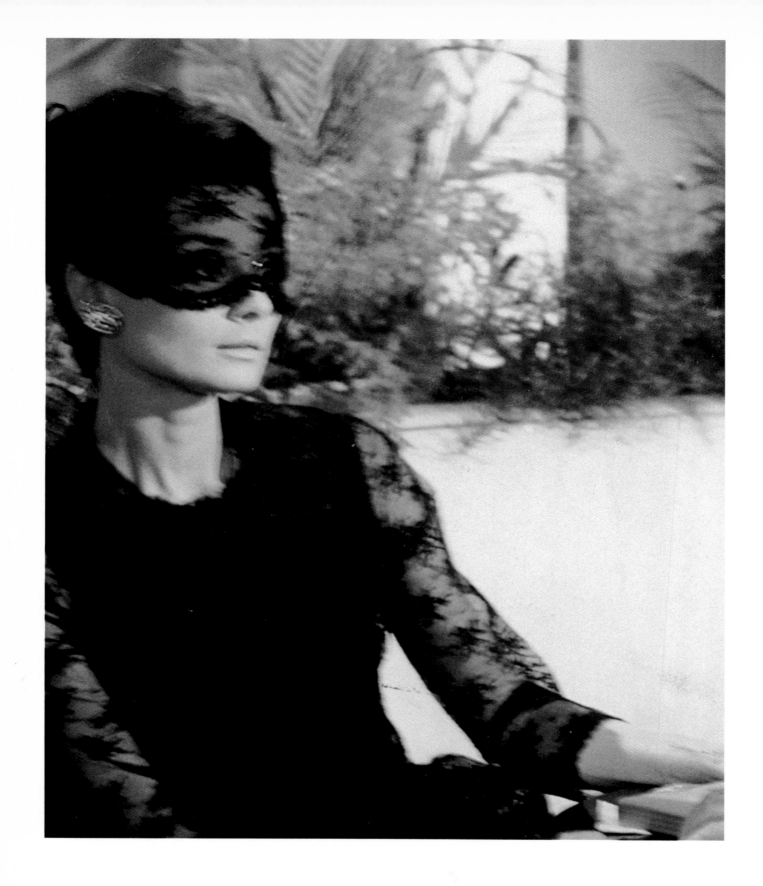

Above:
Audrey Hepburn in William Wyler's film
How to Steal a Million, 1966.

Opposite:
The second Maharani of Baroda celebrating
her husband's 39th birthday in Gujarat (India), Henri Cartier-Bresson, 1946.

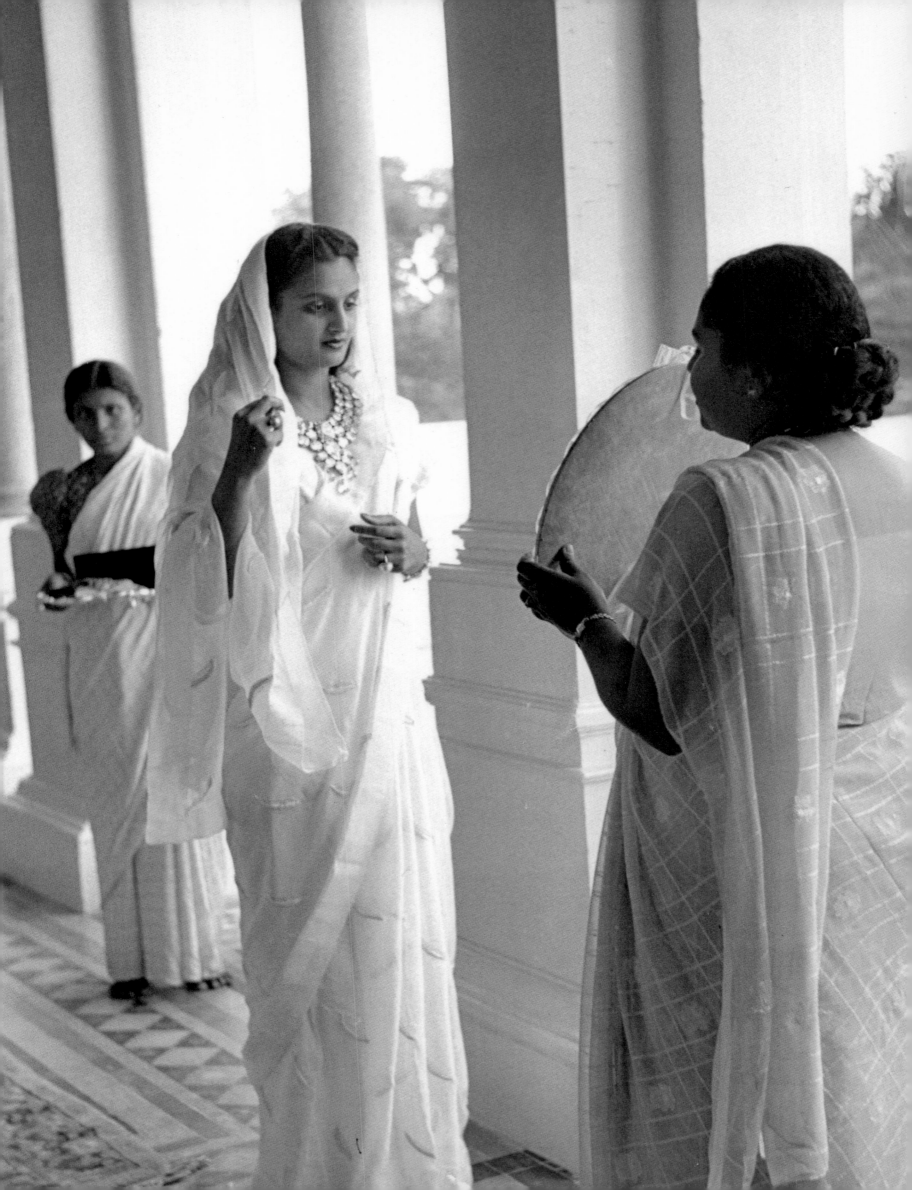

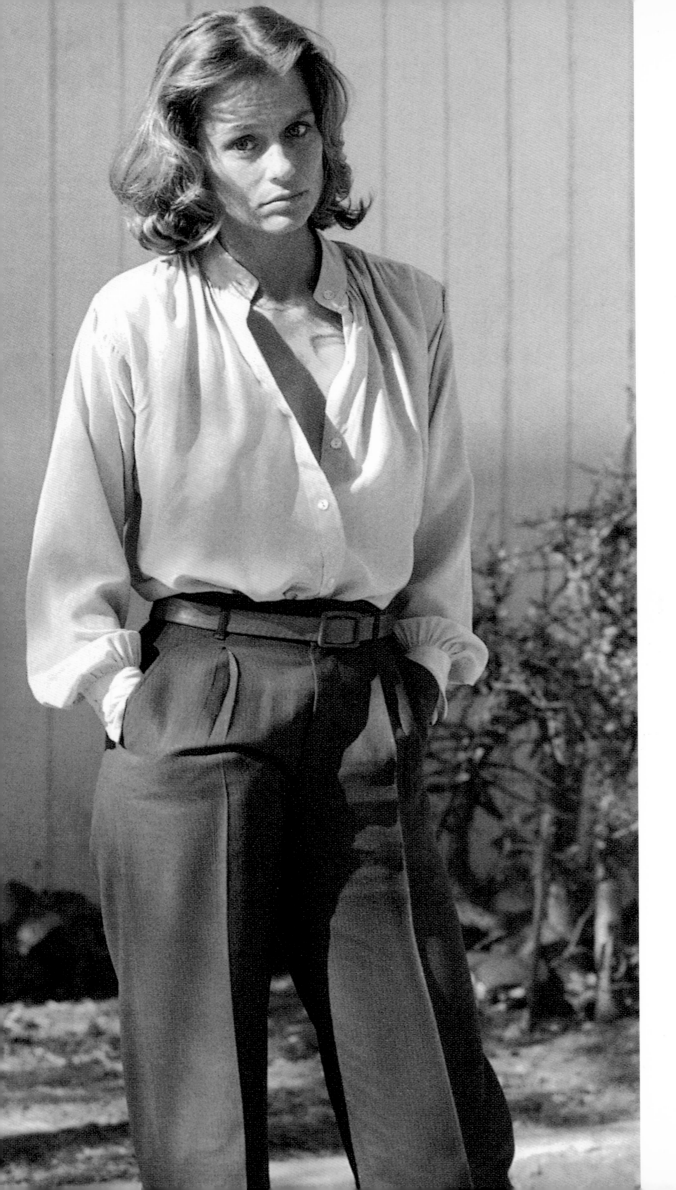

Left:
Laureen Hutton, the most
sought after fashion model in
the United States during the
1970s, photographed by Jim
MacHugh in 1975.

Right:
Yves Saint Laurent's muse,
the unique and inimitable
Betty Catroux. Paris, 2001.

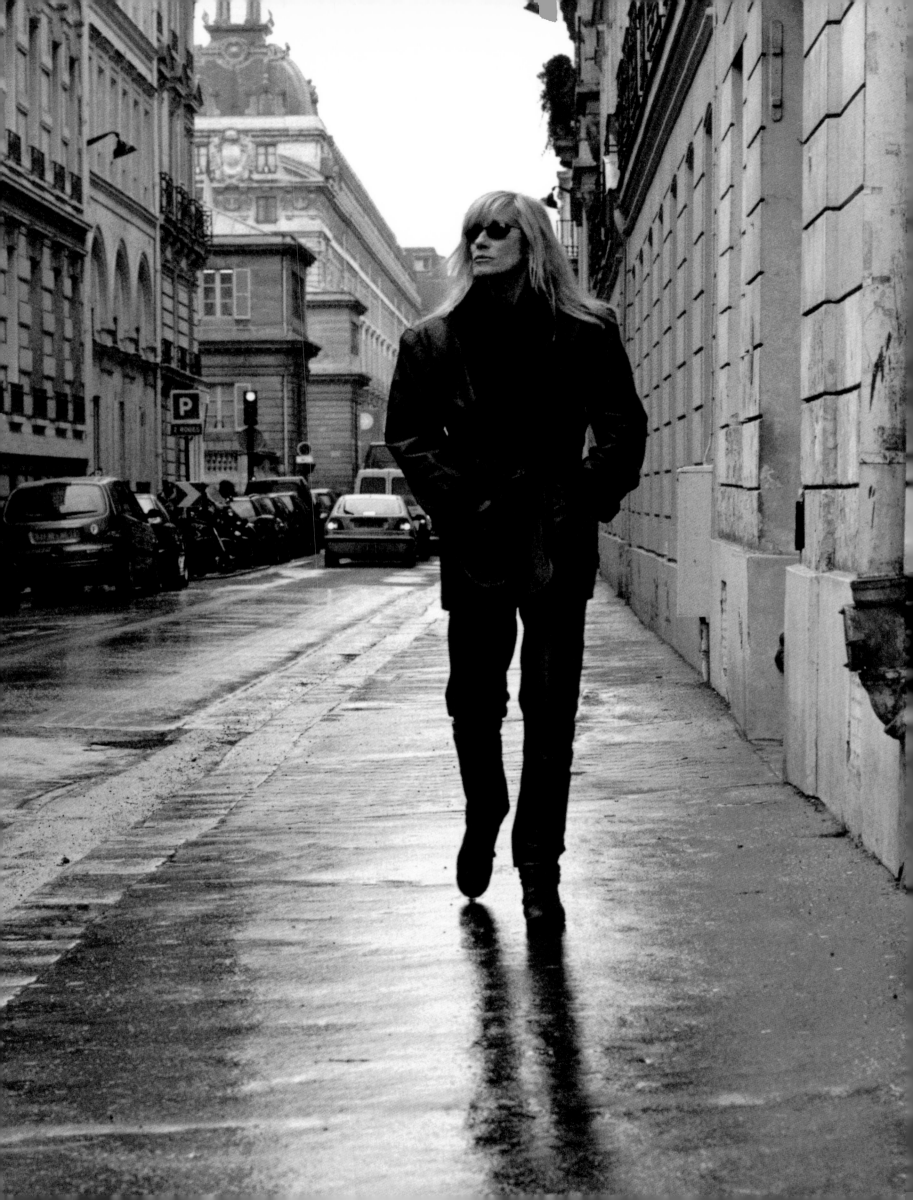

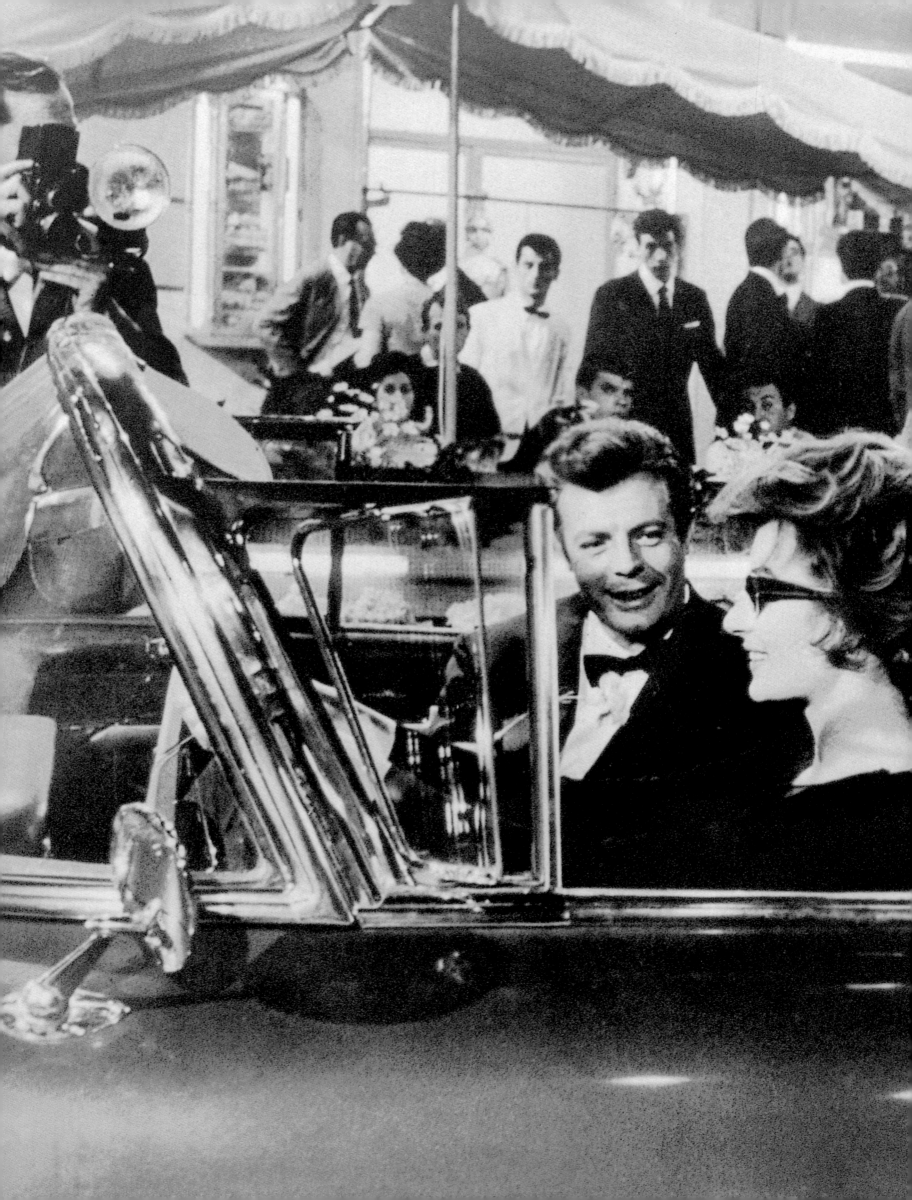

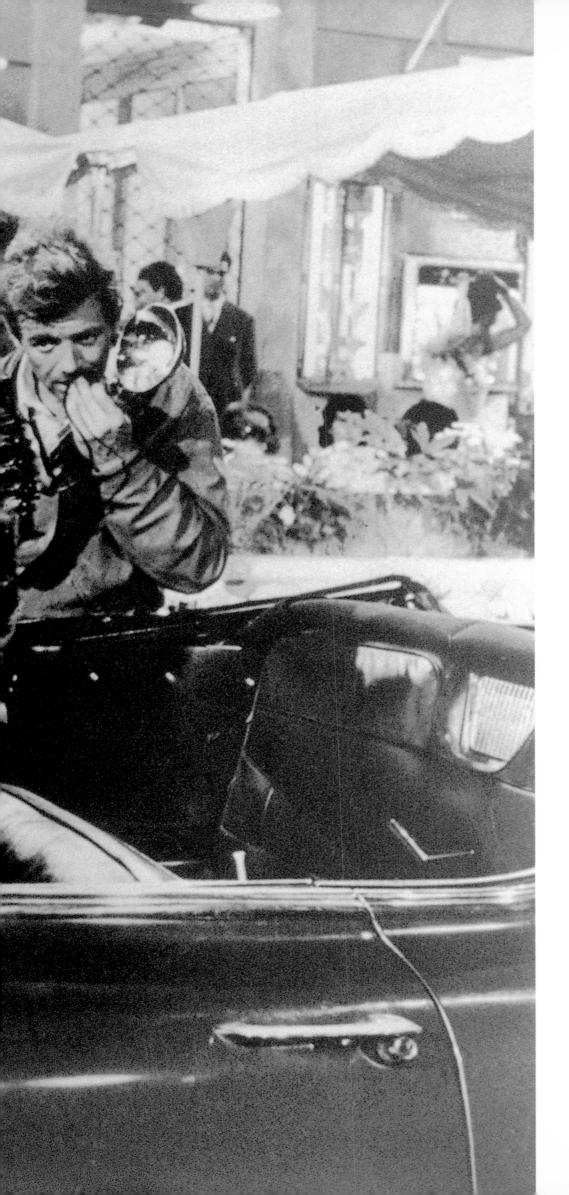

Anouk Aimée and Marcello
Mastroianni in Fellini's film
La Dolce Vita, 1961.

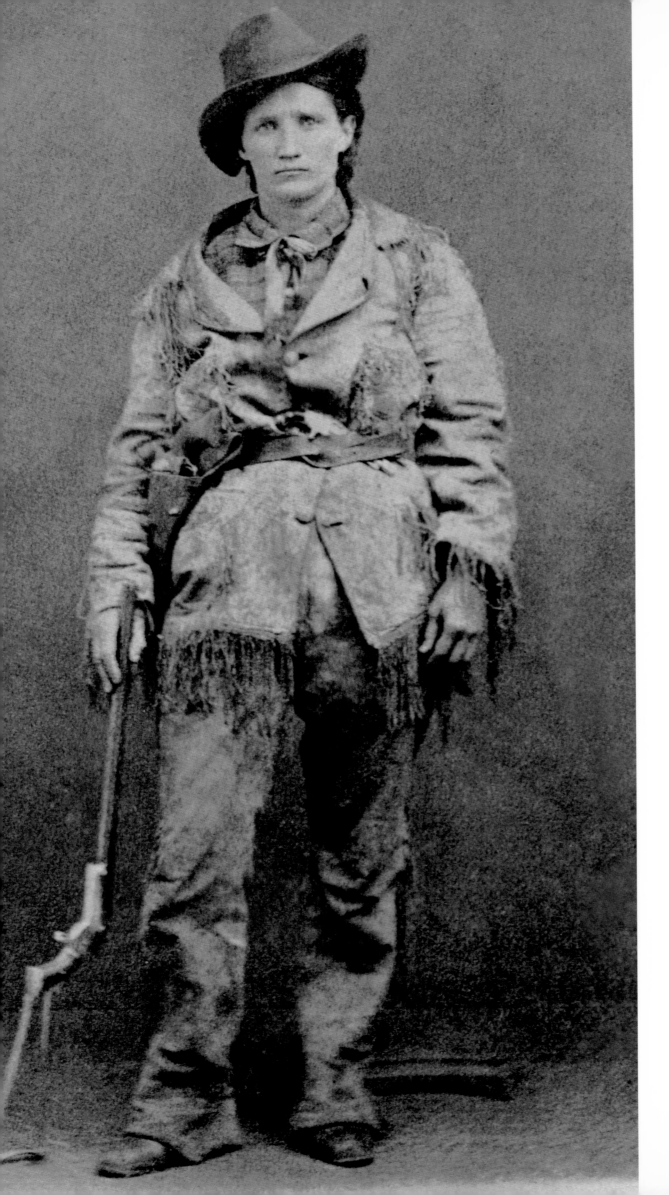

Left:
Portrait of the original
Calamity Jane in the 1880s.

Right:
Maria Callas during a
recording session for
Carmen, 1964.

Following pages:
Hyde Park (London)
in the mist, by Henri Cartier-
Bresson, 1937.

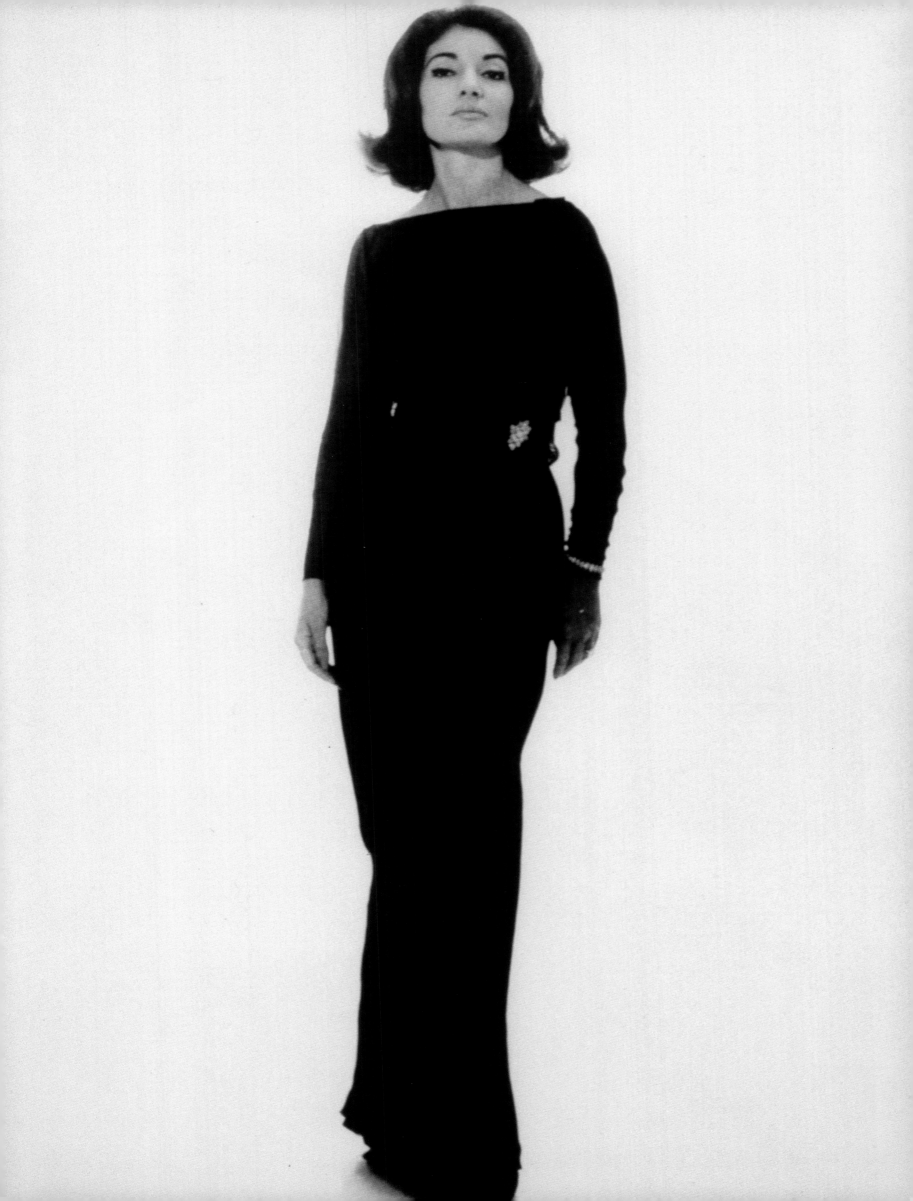

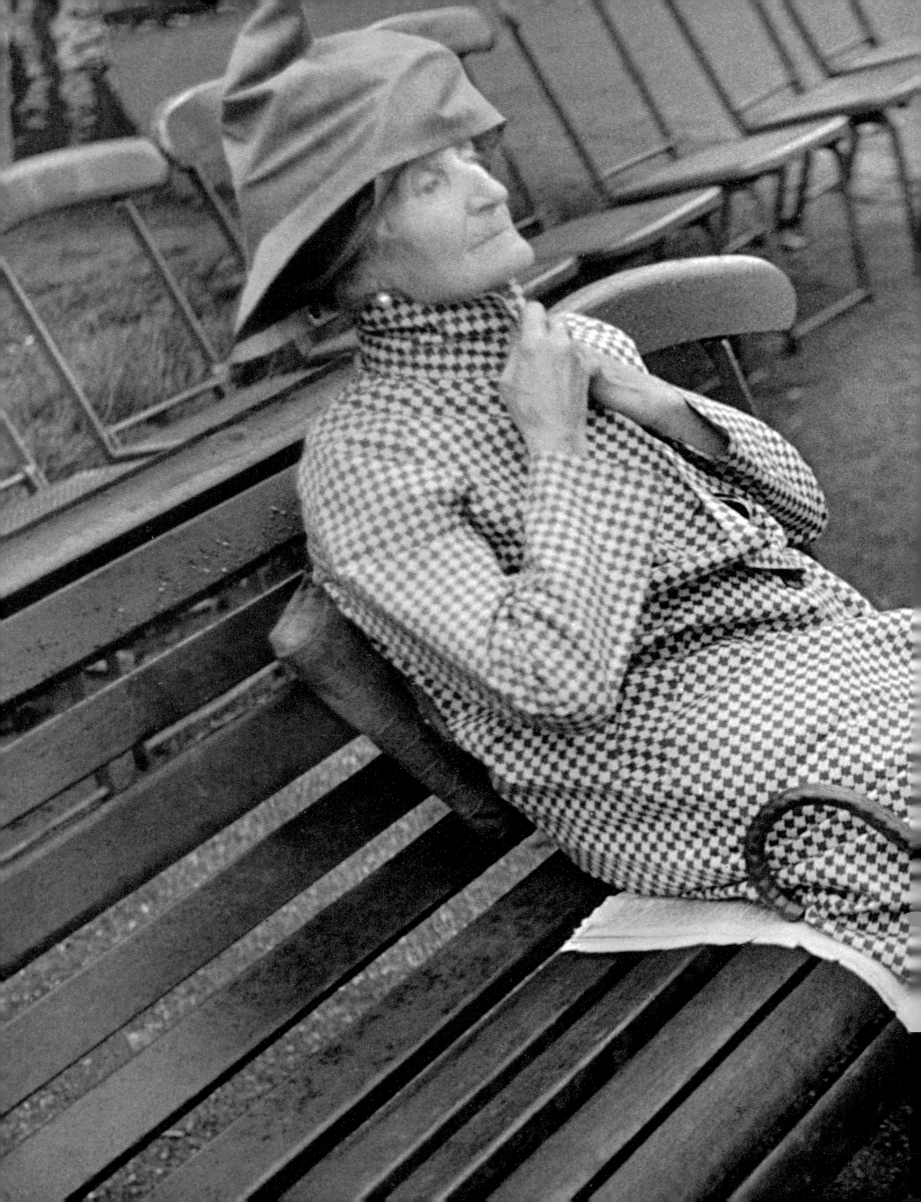

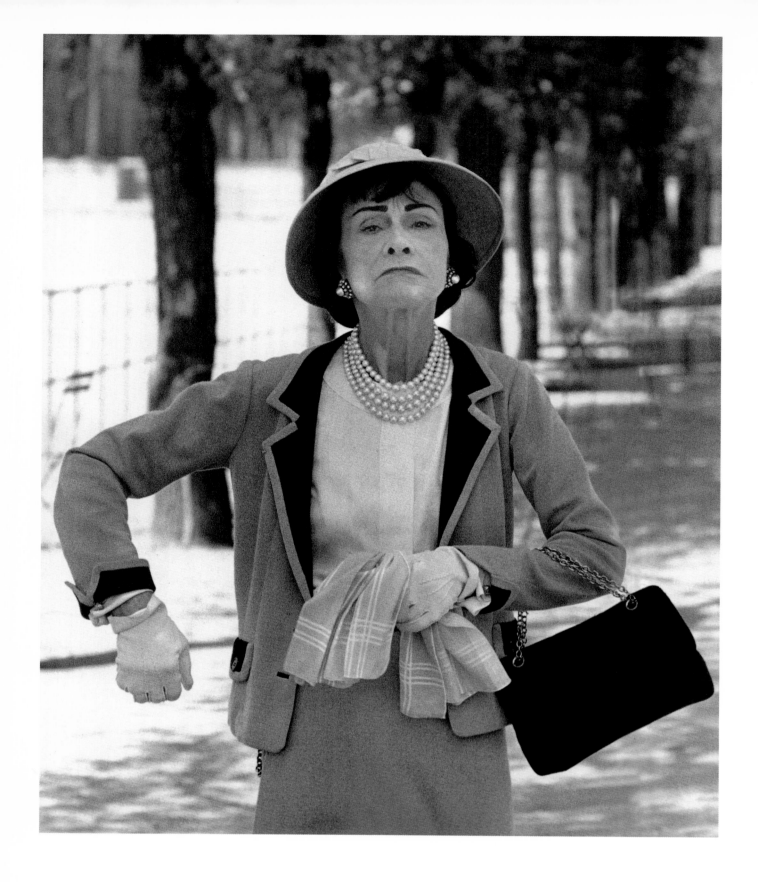

Above:
Mademoiselle Chanel in the Tuileries Gardens,
explaining the design of her sleeve to Alexander Liberman, 1951.

Opposite:
Muhammad Ali's daughter, Laila,
by Gilles Bensimon, 2001.

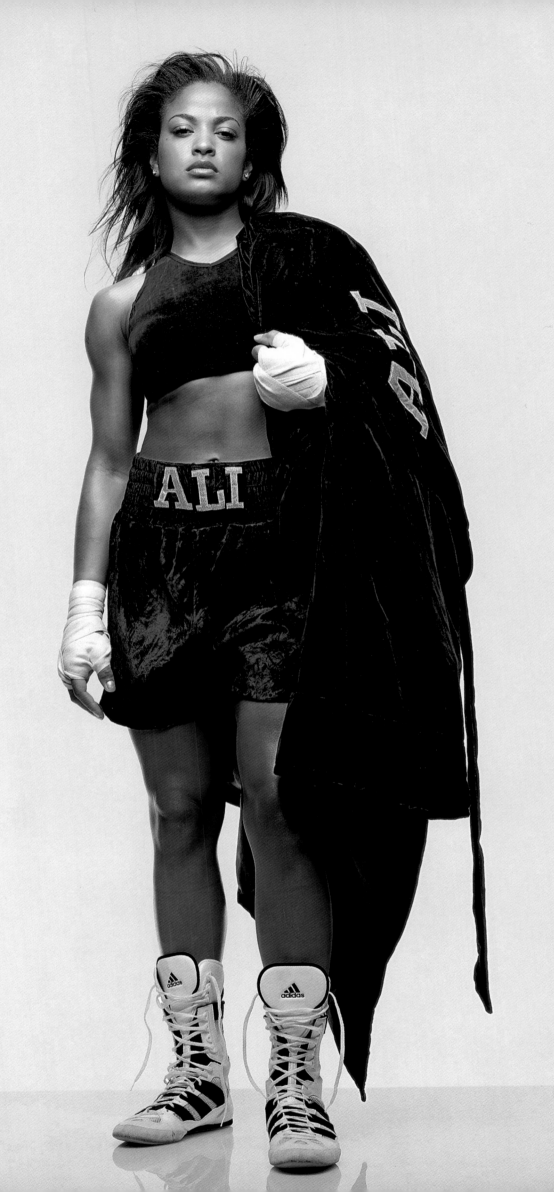

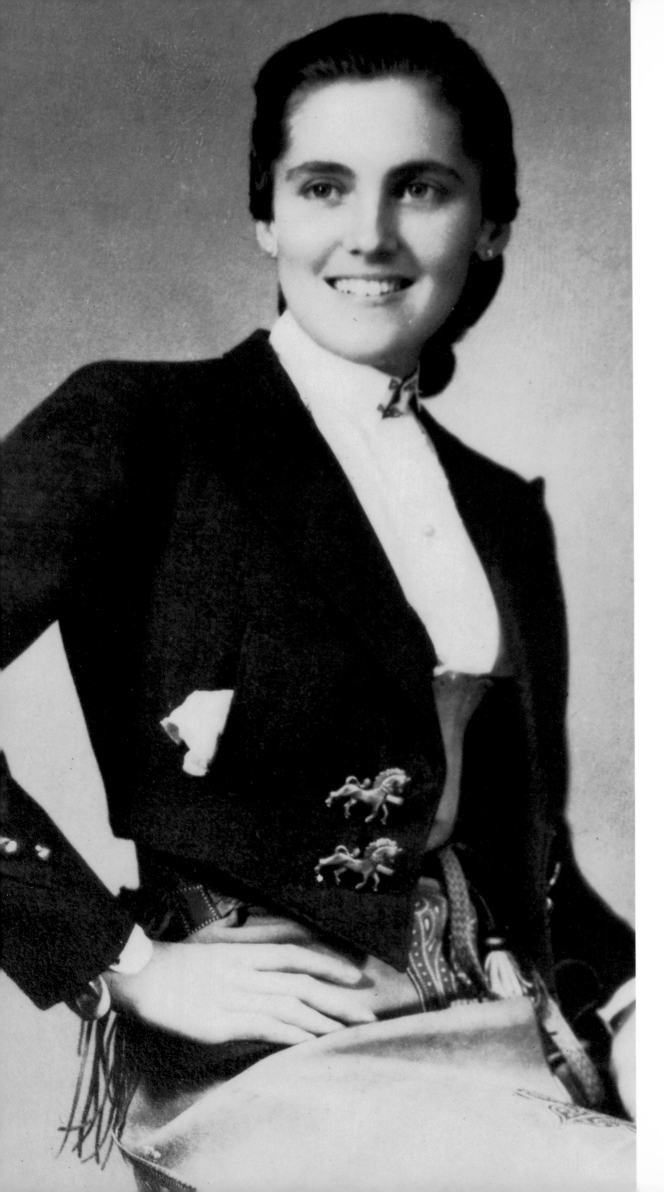

Left:
Mounted bullfighter Conchita
Cintron, idol of the Spanish
bull rings in the 1930s.

Right:
Margot, by Rudolf Schliter,
1924.

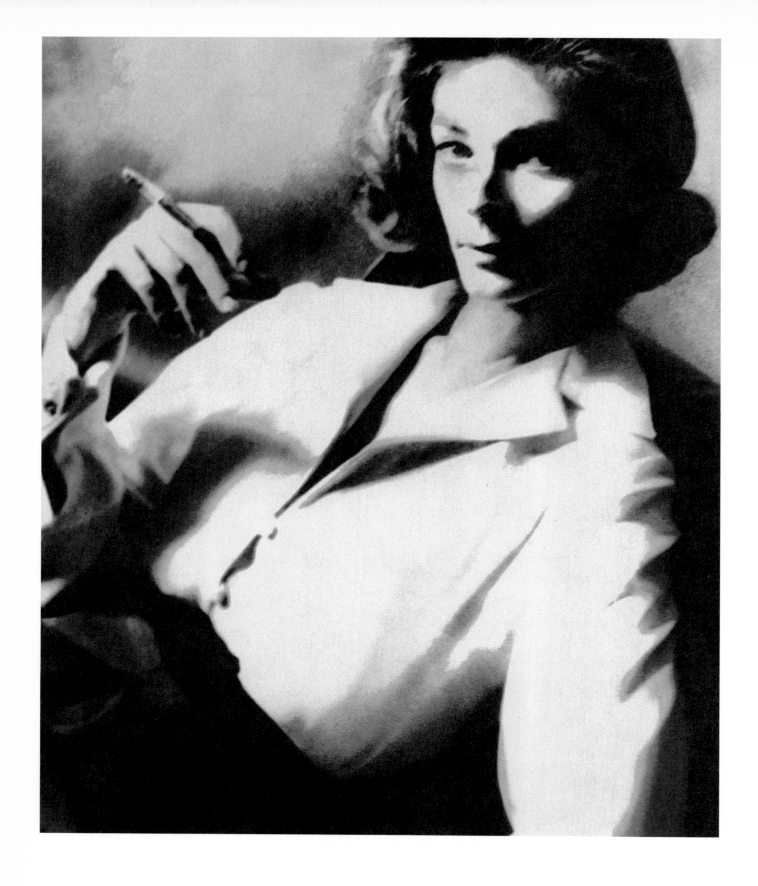

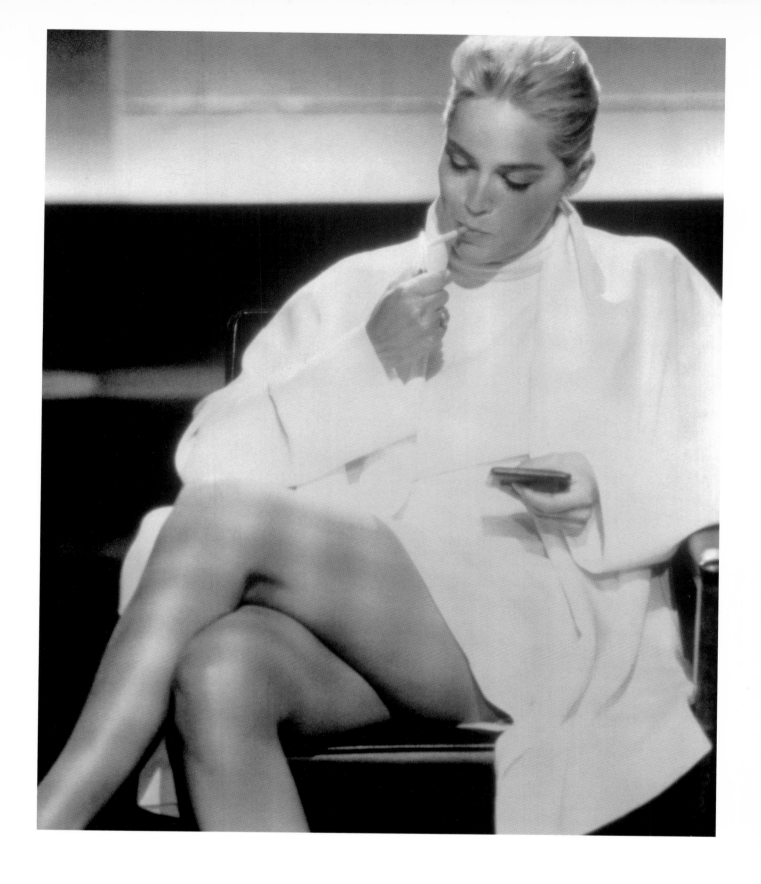

Opposite:
Lauren Bacall, photographed by
Lillian Bassman for *Harper's Bazaar*, 1963.

Above:
Sharon Stone in Paul Verhoeven's film *Basic Instinct*, 1992.

Above:
The 1990s: Alek, by Gilles Bensimon.

Opposite:
Dress by Osimar Versolato for Lanvin, Winter 1996–97
Collection, photographed by Christophe Kutner.

Following pages:
Portrait of Diana Vreeland, by Deborah Turbeville, 1980.

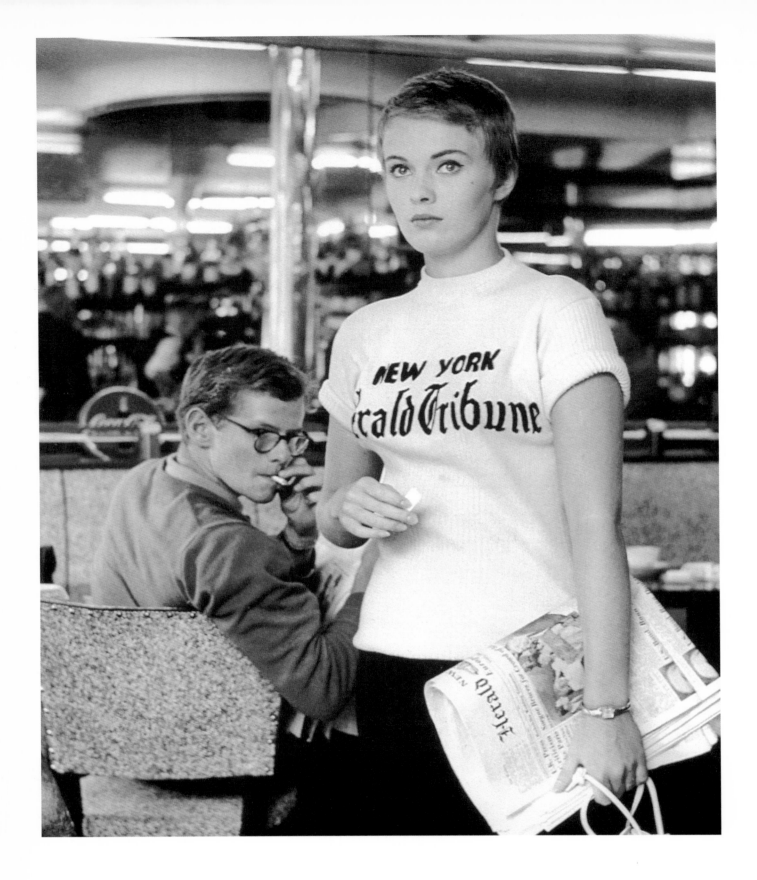

Above:
Jean Seberg on the set of
Jean-Luc Godard's film *Breathless*, 1959.

Opposite:
Jeanne Moreau in Jacques Demy's film
La Baie des Anges, 1963.

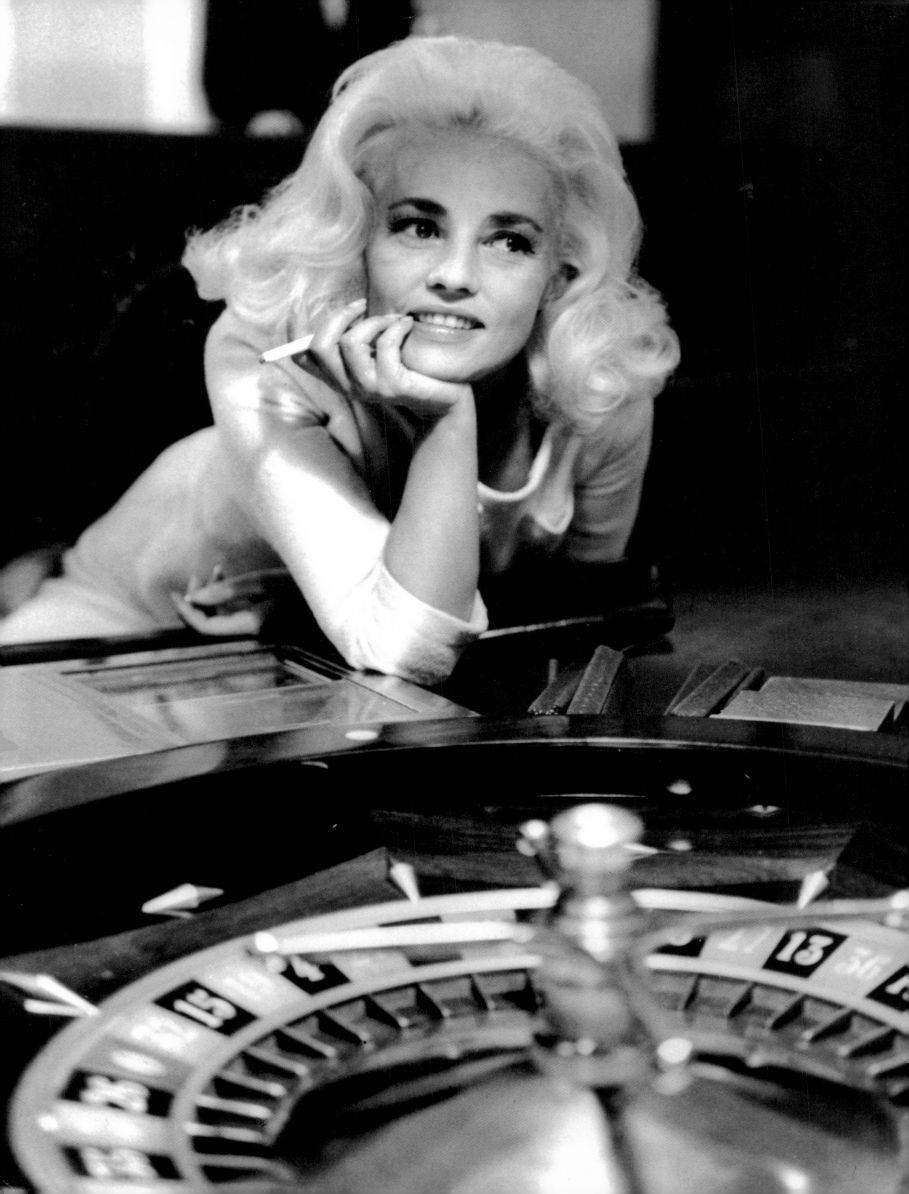

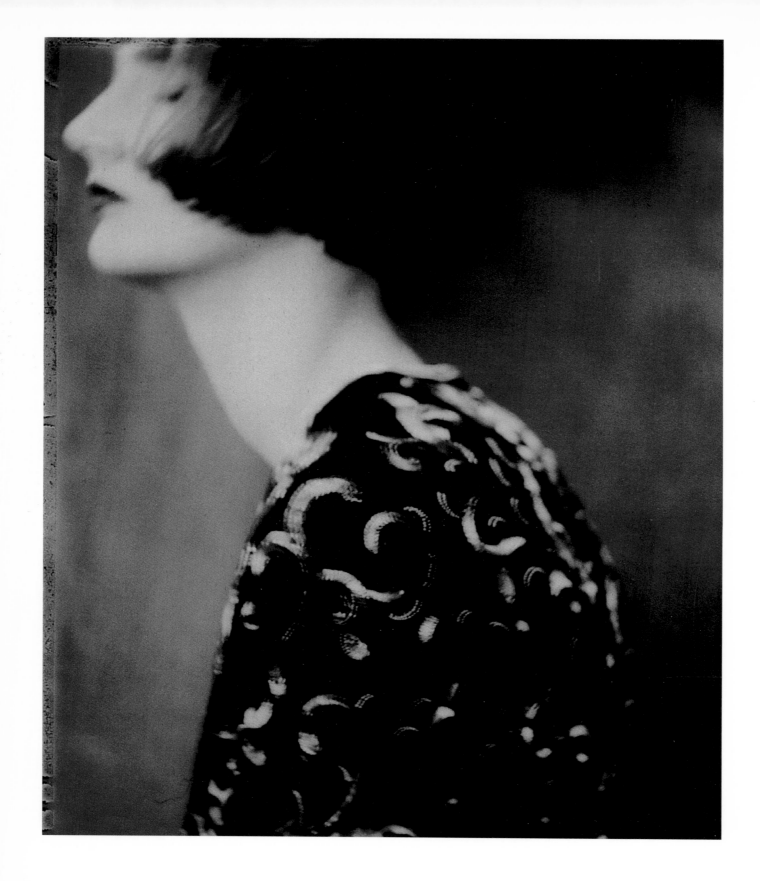

Above:
Woman's profile, by Sarah Moon, 1993.

Opposite:
Inès de la Fressange, by Gilles Bensimon, circa 1987.

Following pages:
Lisa Fonssagrives, photographed by
Lillian Bassman for *Harper's Bazaar*, 1963.

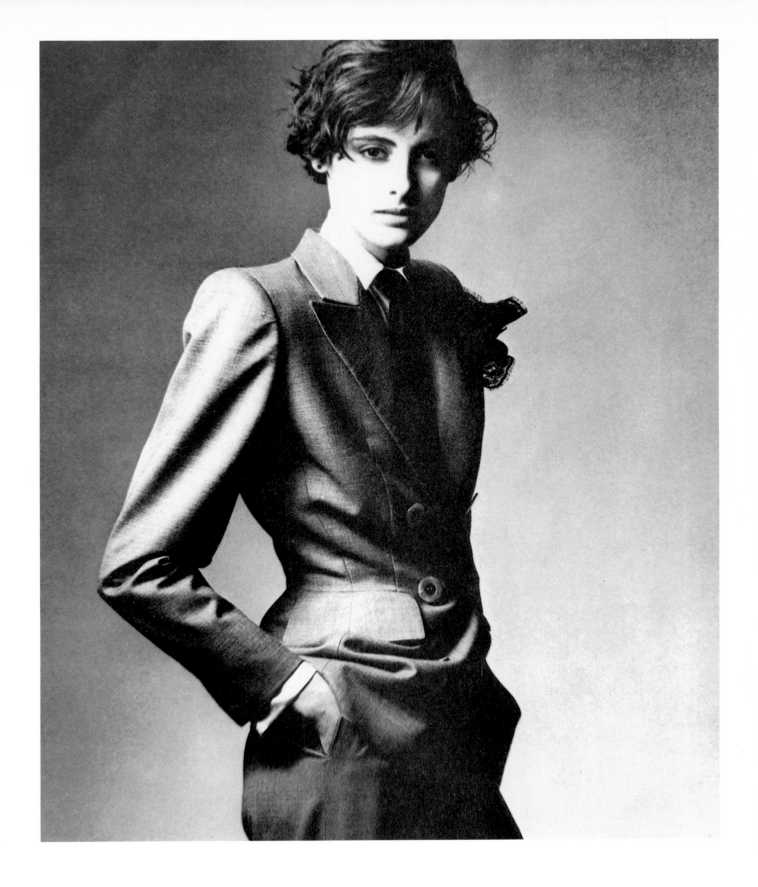

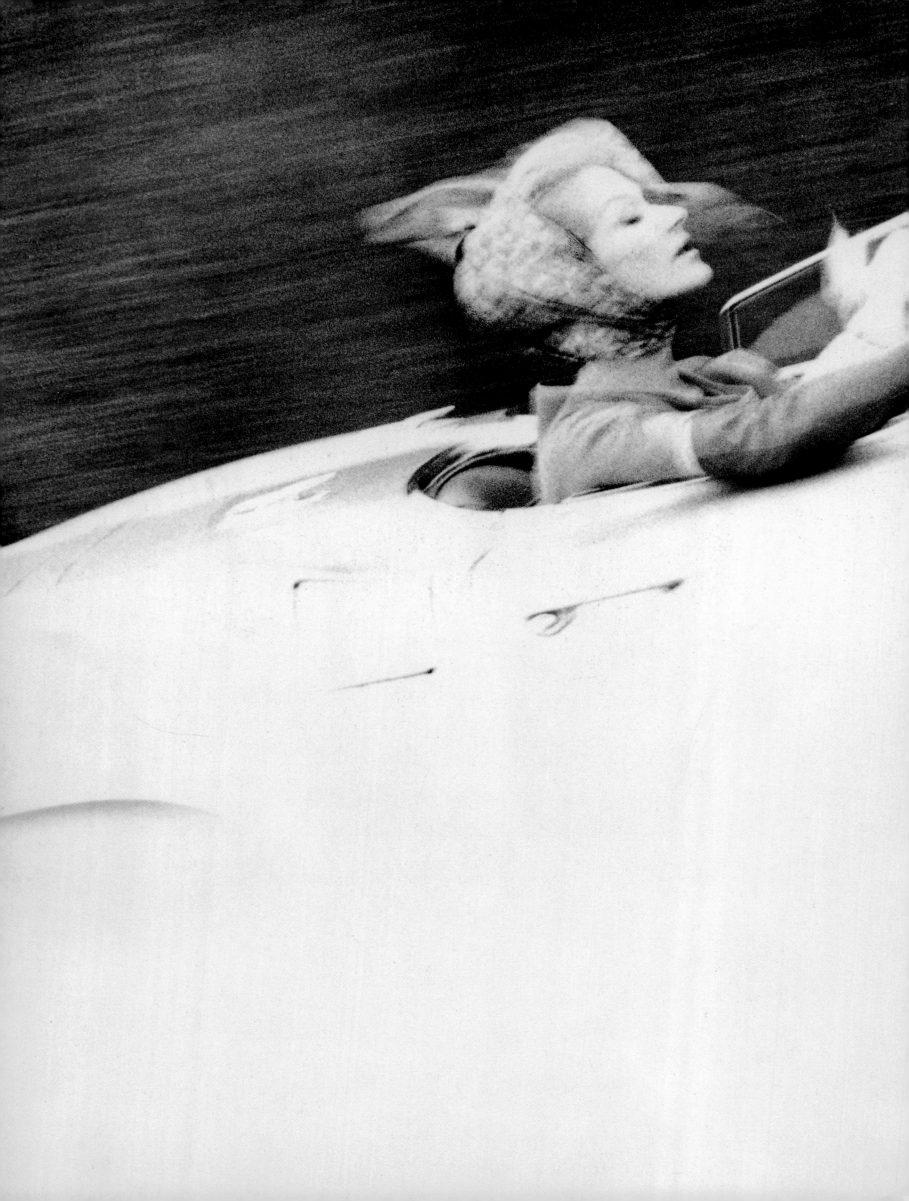

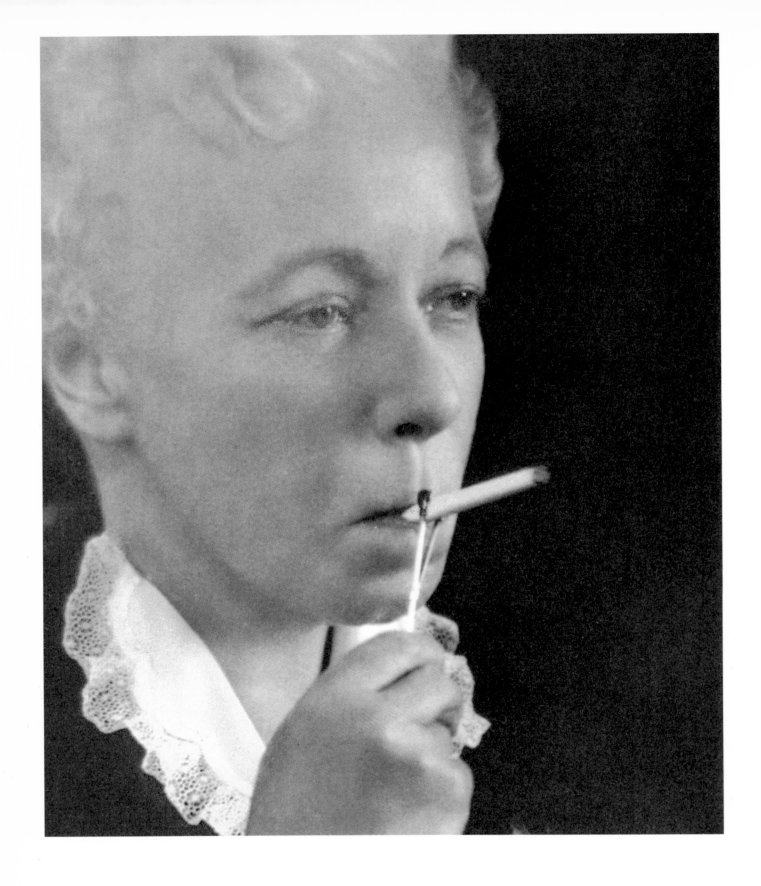

Above:
Psychoanalyst Karen Horney (1885–1952), 1947.

Opposite:
Venice, by Gianni Berengo Gardin, 1968.

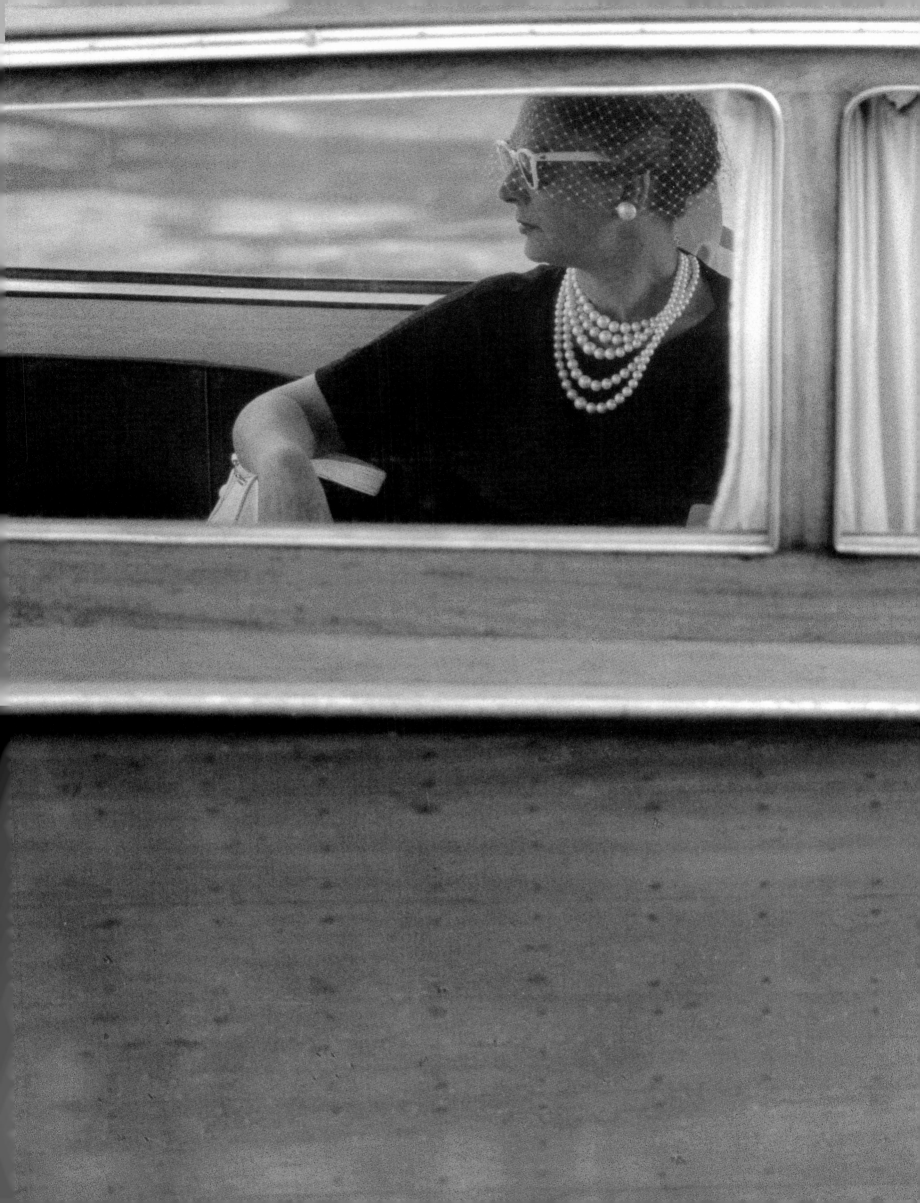

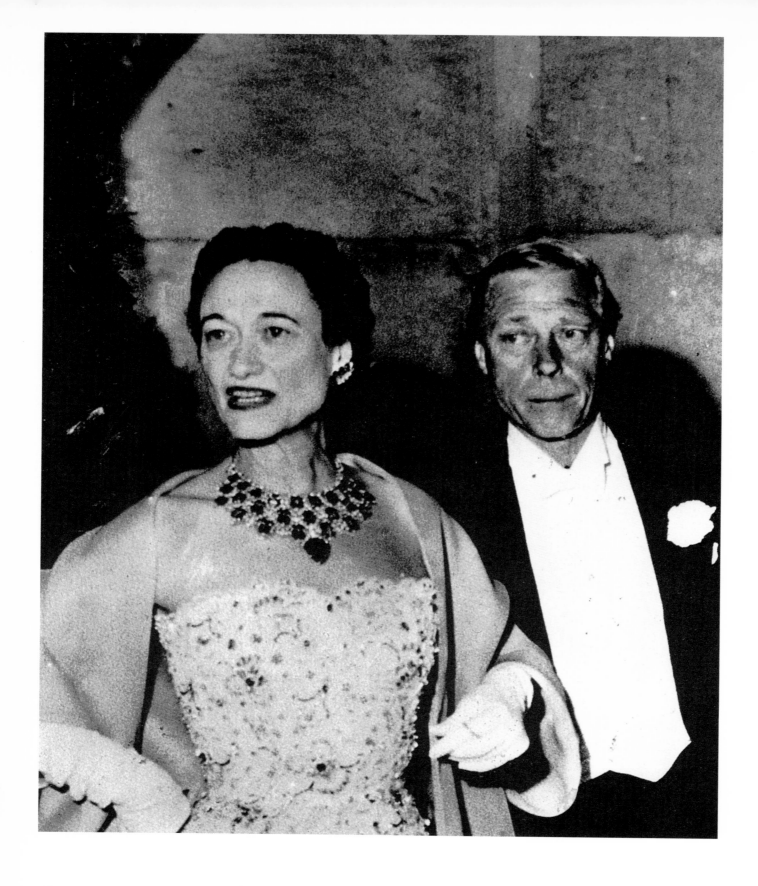

Above:
The Duke and Duchess of Windsor
attending a gala dinner at Versailles, June 1953.

Opposite:
Women's Legs, by Edward Steichen.

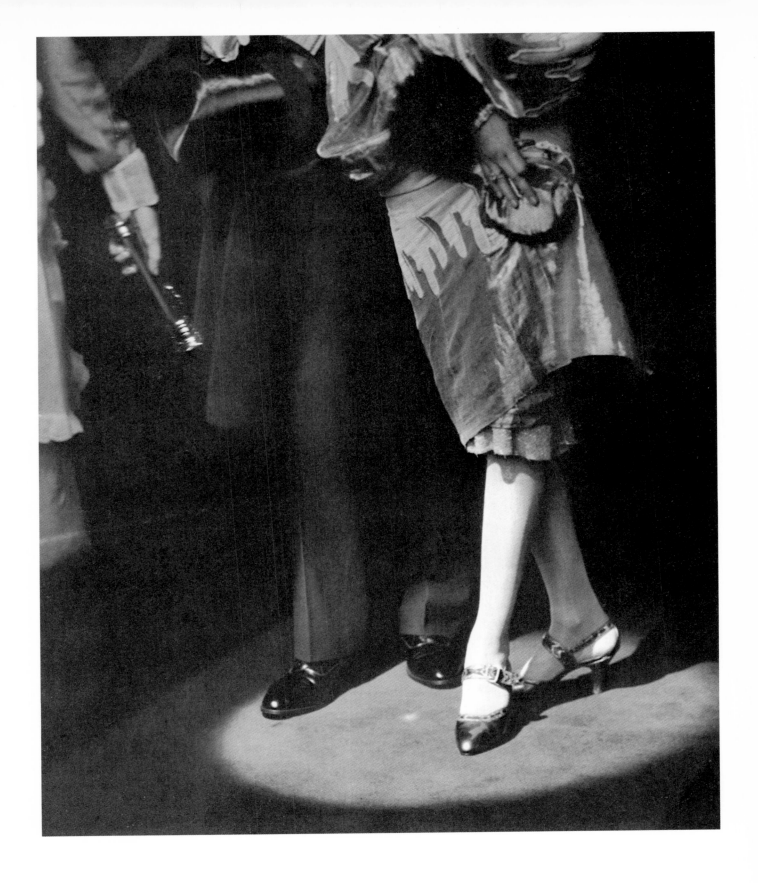

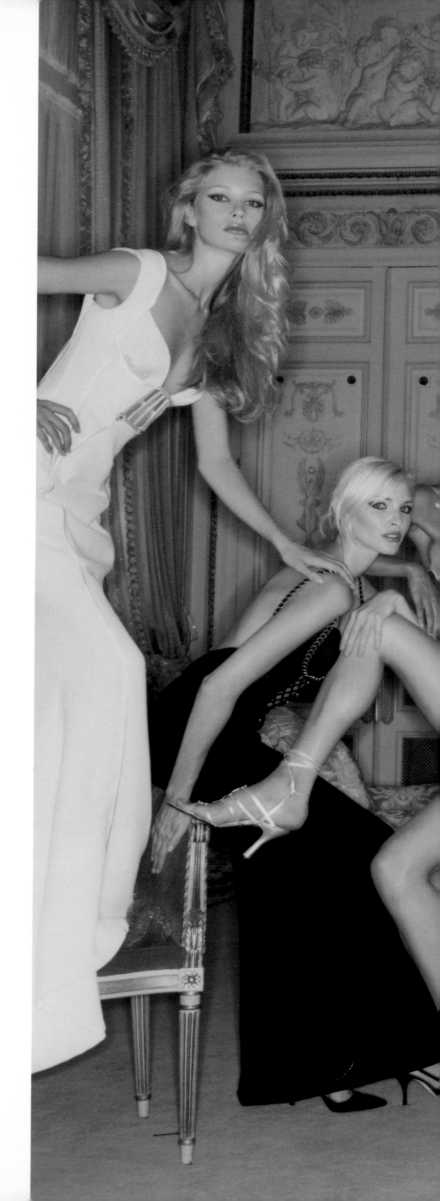

Top models wearing clothes
from the Gianni Versace
Autumn/Winter 1994–95
Collection, photographed by
Michel Comte.

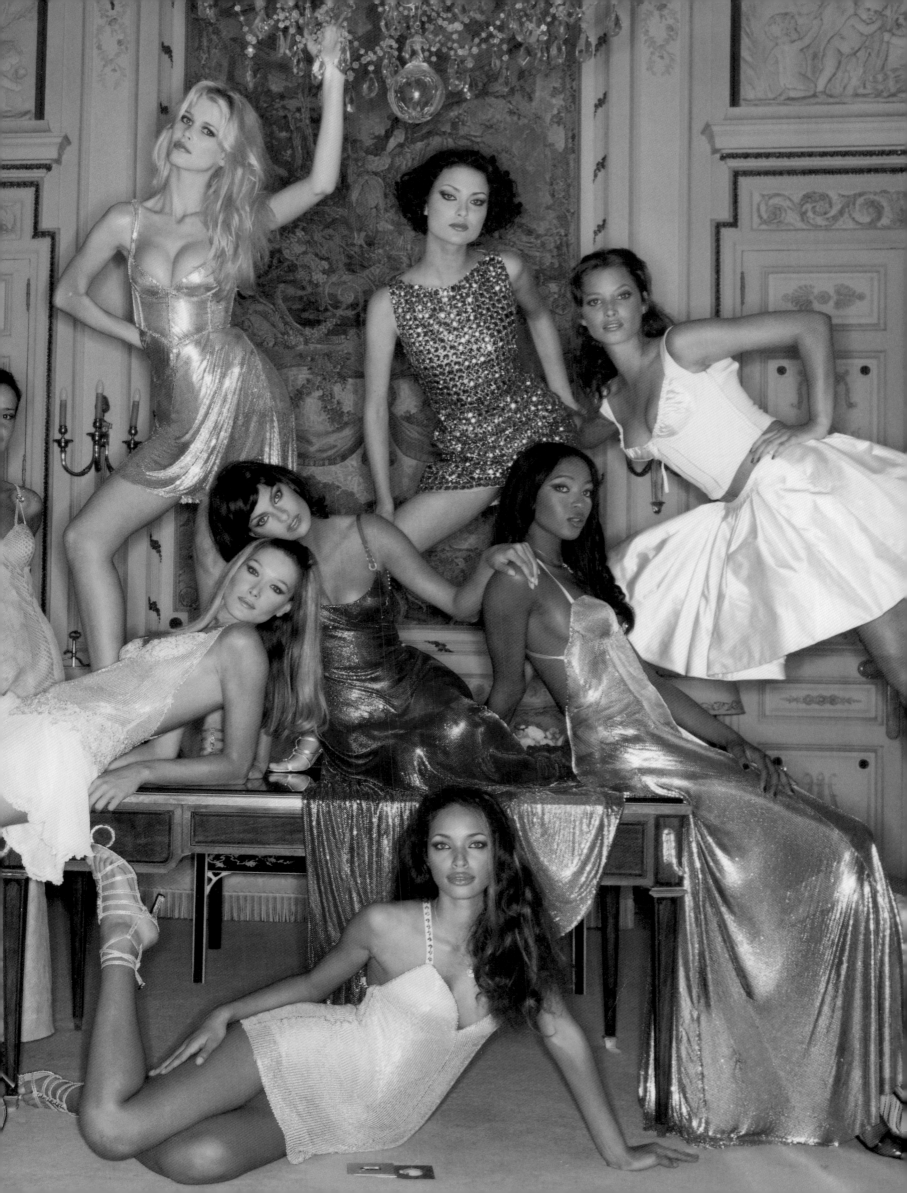

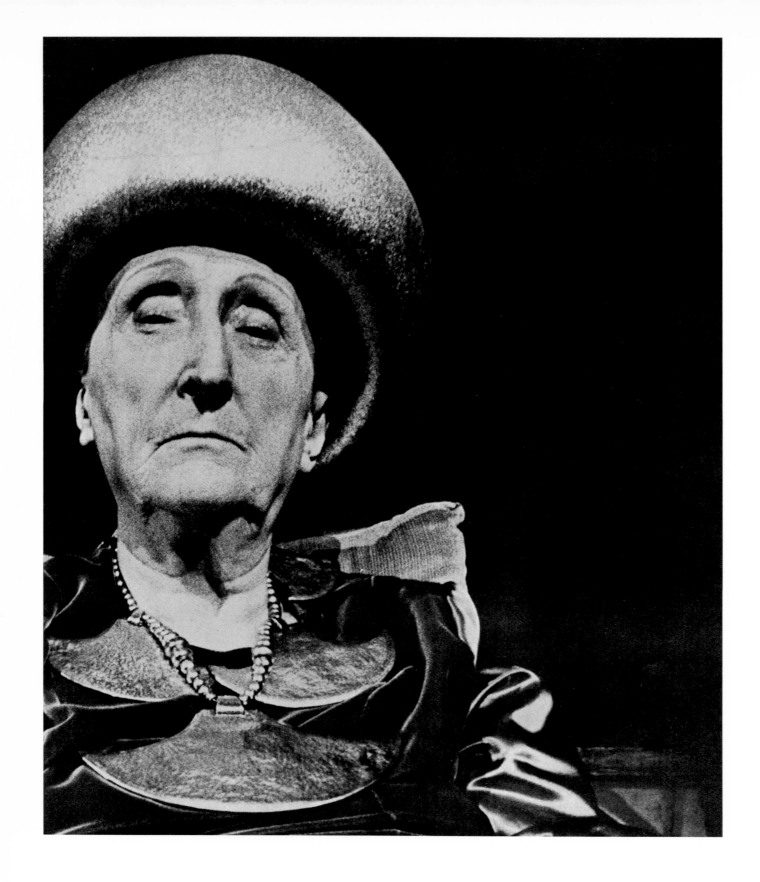

Above:
Edith Sitwell celebrating her 75th birthday in London, 1962.

Opposite:
Woman from the Mangebetu tribe.

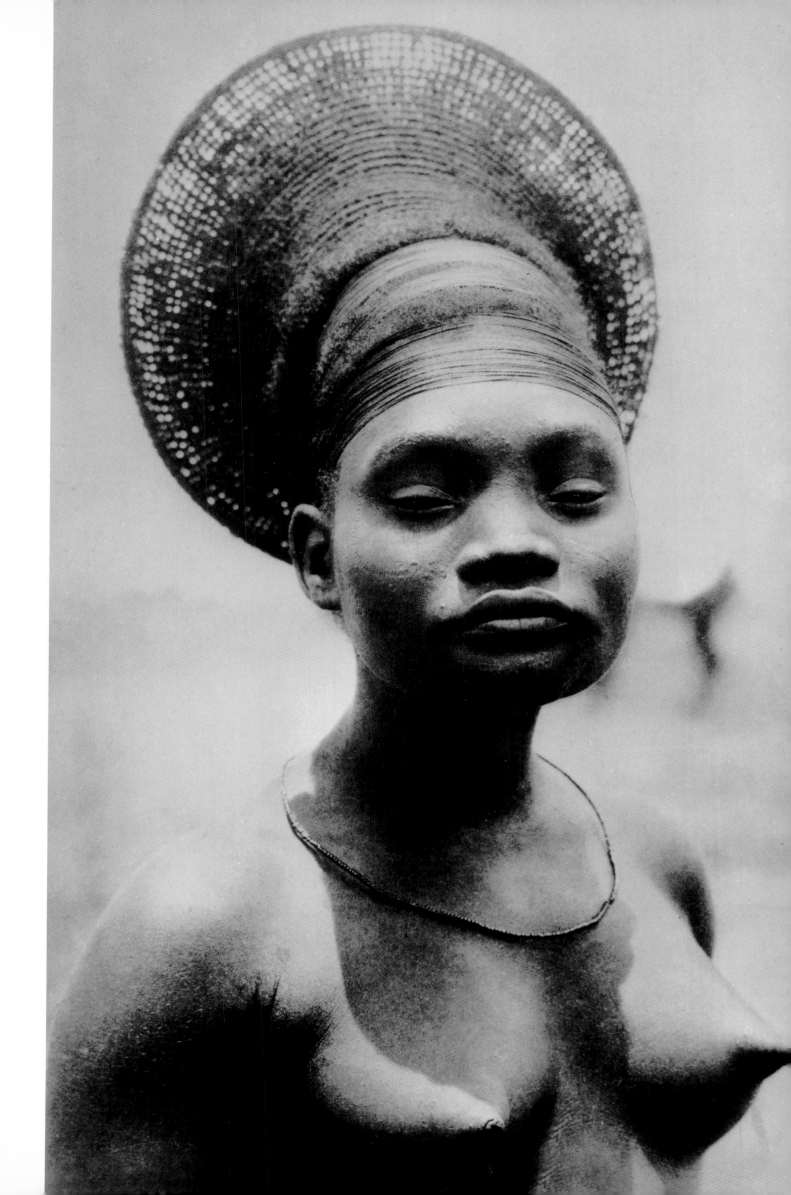

Above:
Silvana Mangano in Giuseppe De Santis's film *Bitter Rice*, 1948.

Opposite:
Anna Magnani.

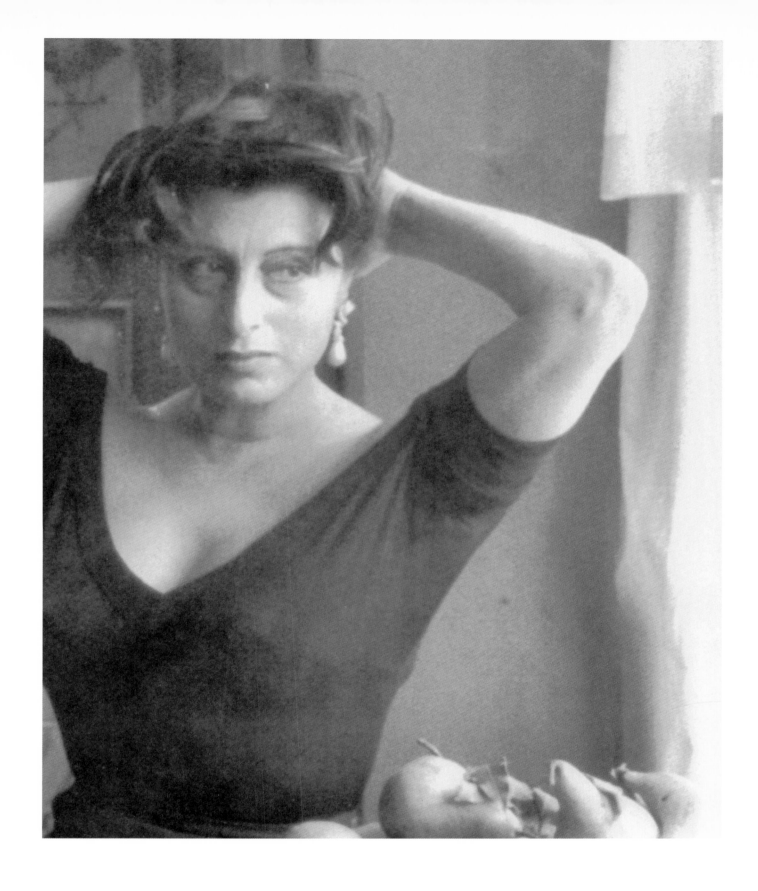

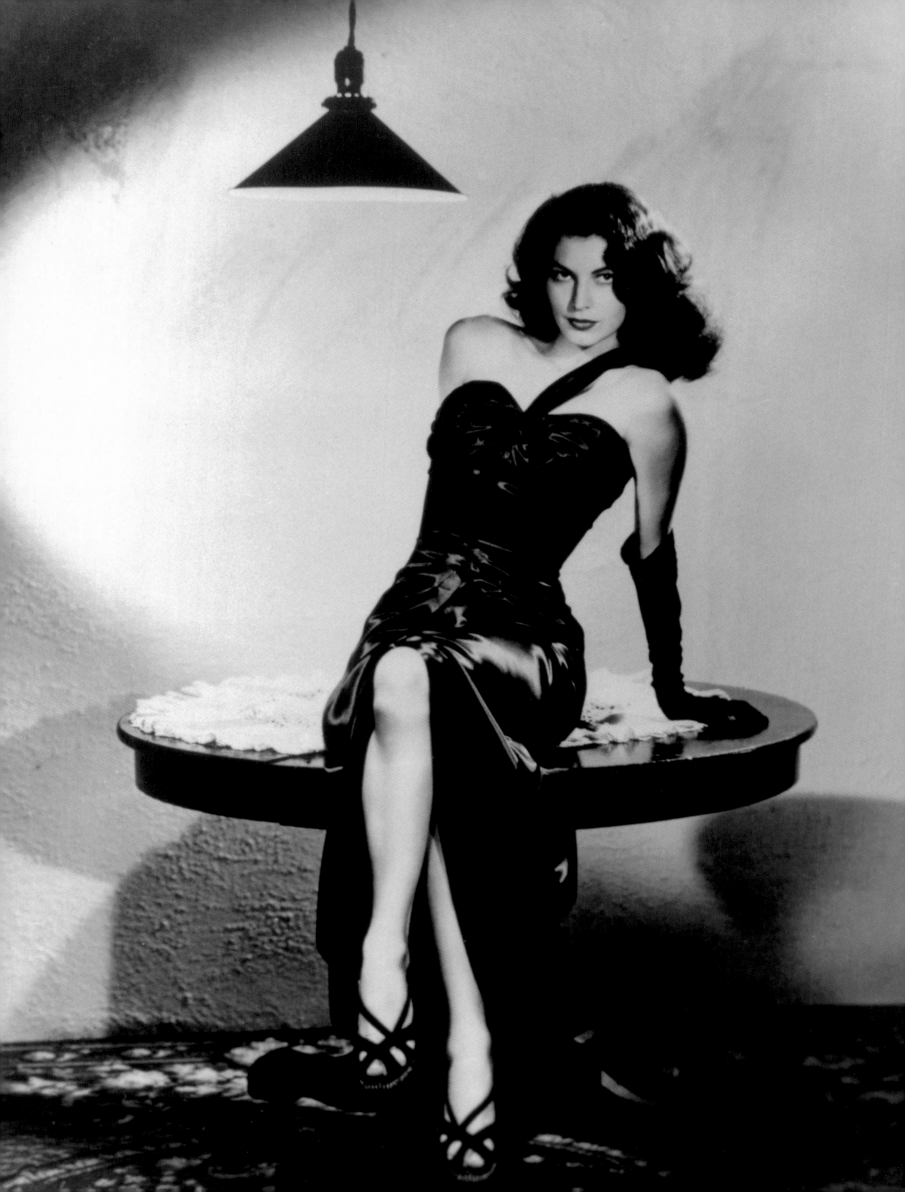

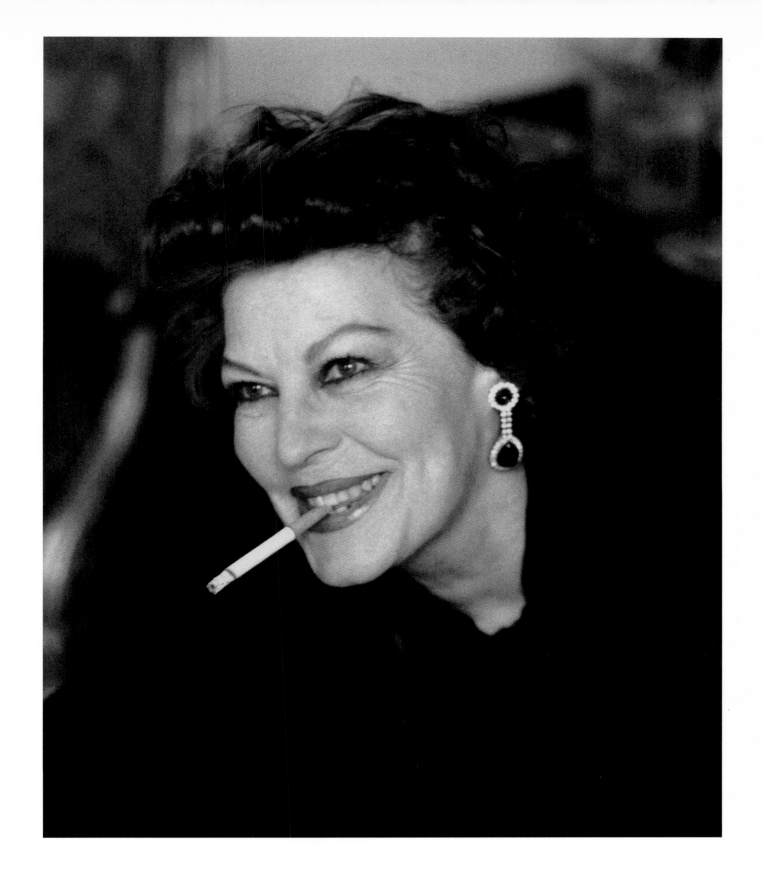

Above:
Ava Gardner, by Helmut Newton, London, 1984.

Opposite:
Ava Gardner in Robert Siodmak's film *The Killers*, 1946.

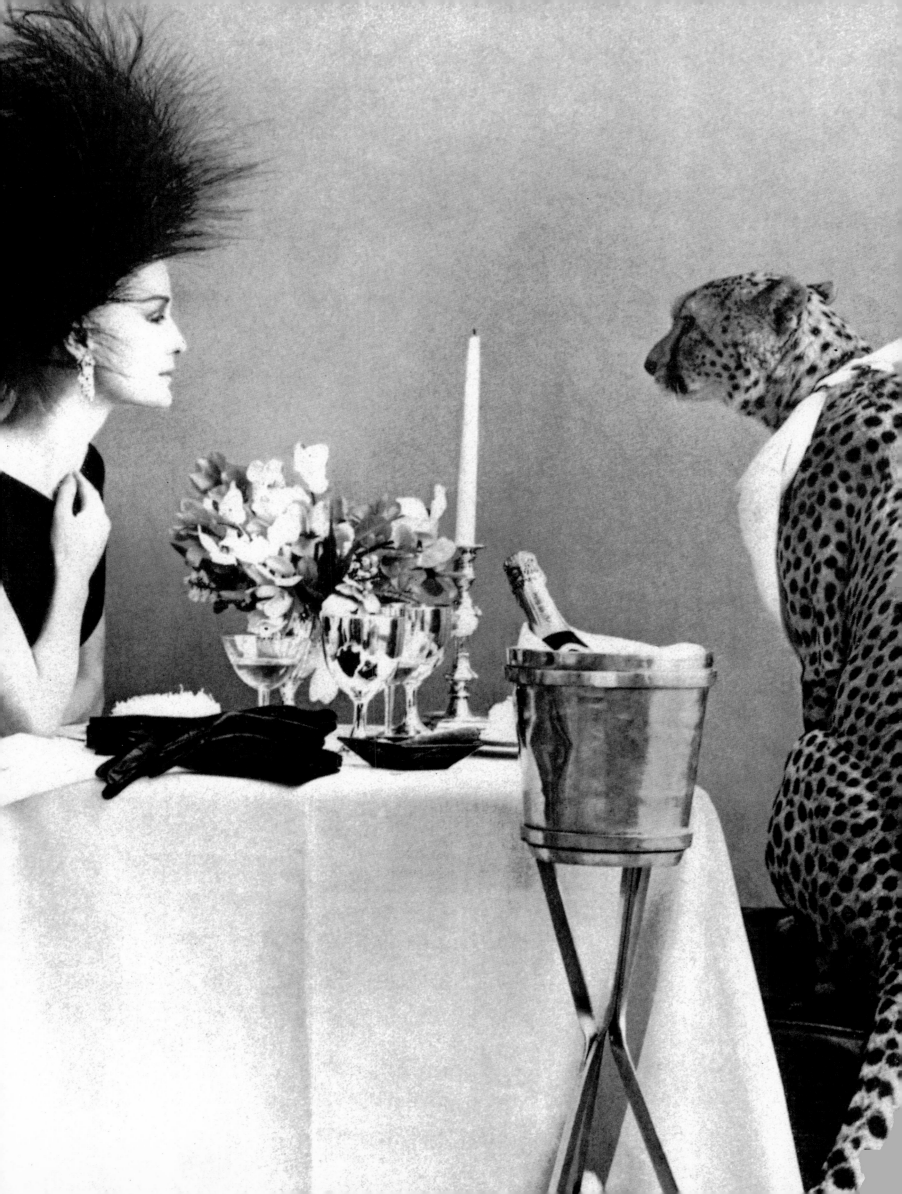

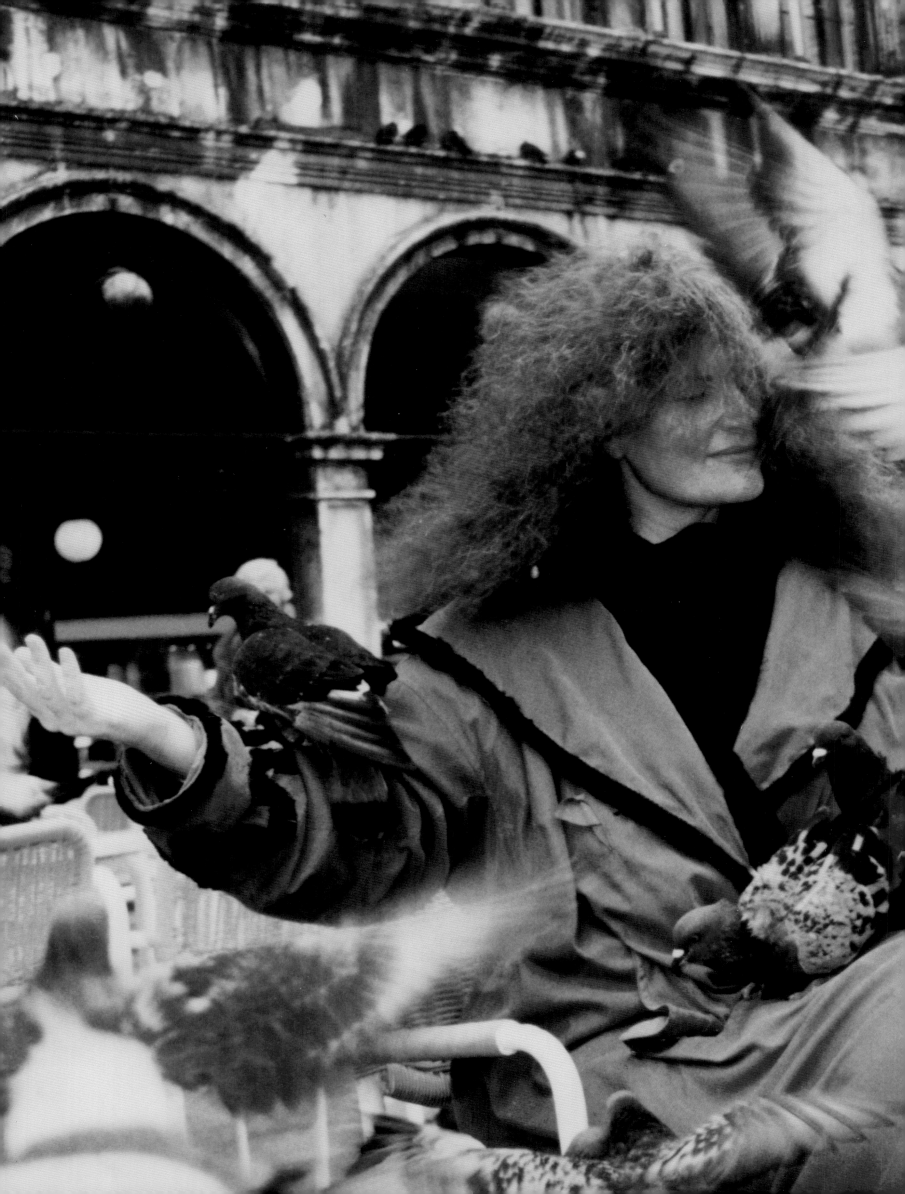

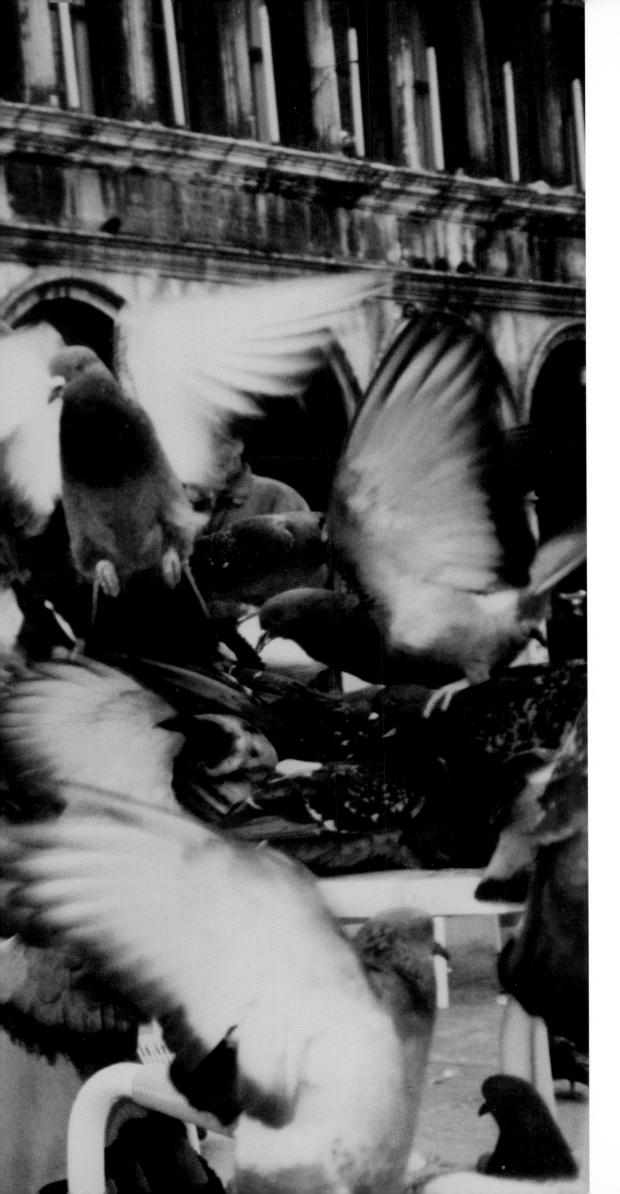

Opposite:
Nicole Wizniack, photographed by a friend on the Piazza San Marco, Venice, 1990.

Following pages:
(left)
Fran Lebowitz and Tina Chow attending a charity ball at the Hotel Pierre in New York, 1980.
(right)
Fashion model Devon photographed by Karl Lagerfeld for Chanel, 2001.

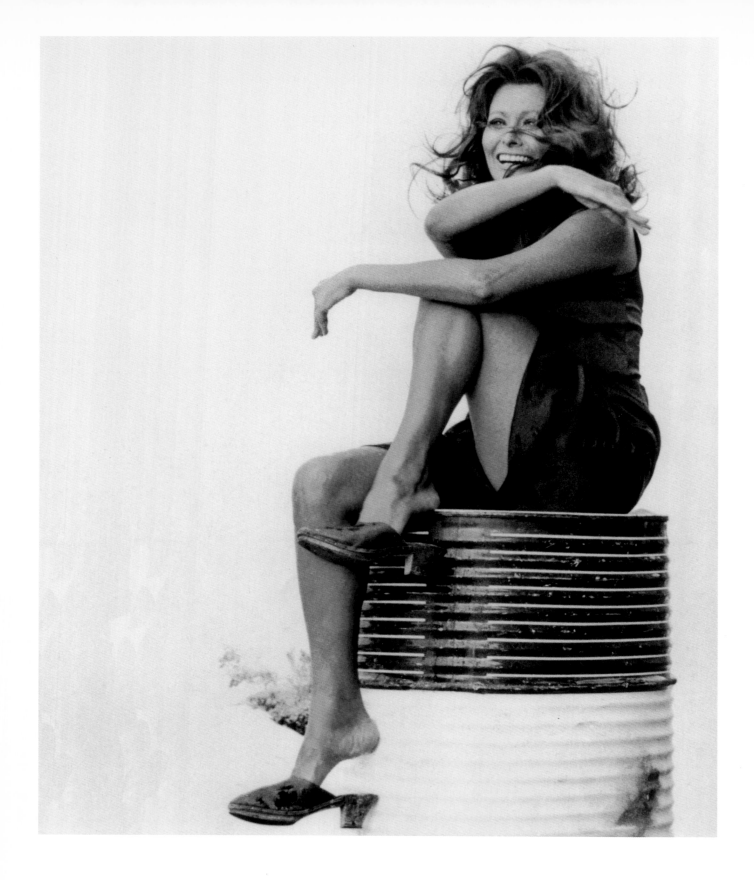

Above:
Sophia Loren taking a break on the set of
The Sin, Almeria (Spain), 1971.

Opposite:
Brigitte Bardot on the set of
Jean-Luc Godard's film *Contempt*, Capri, 1963.

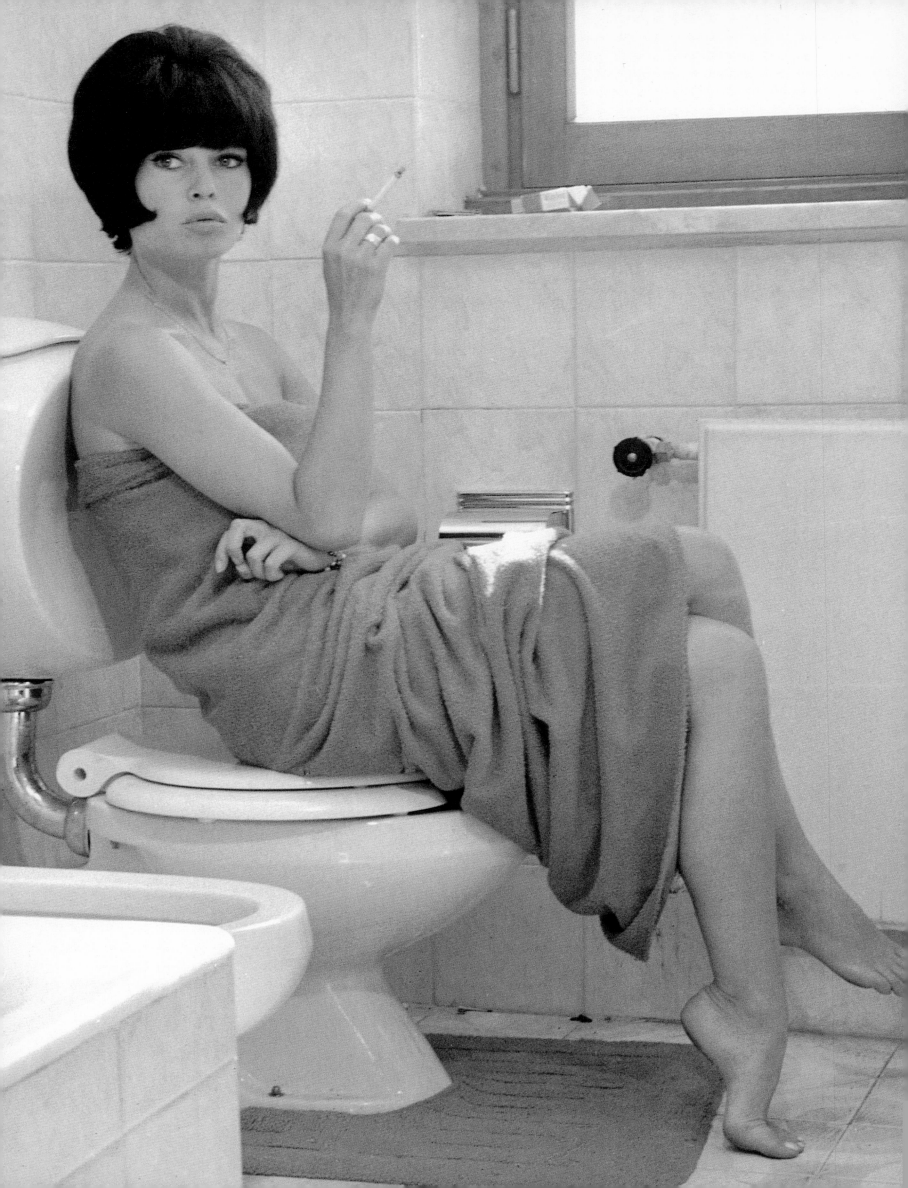

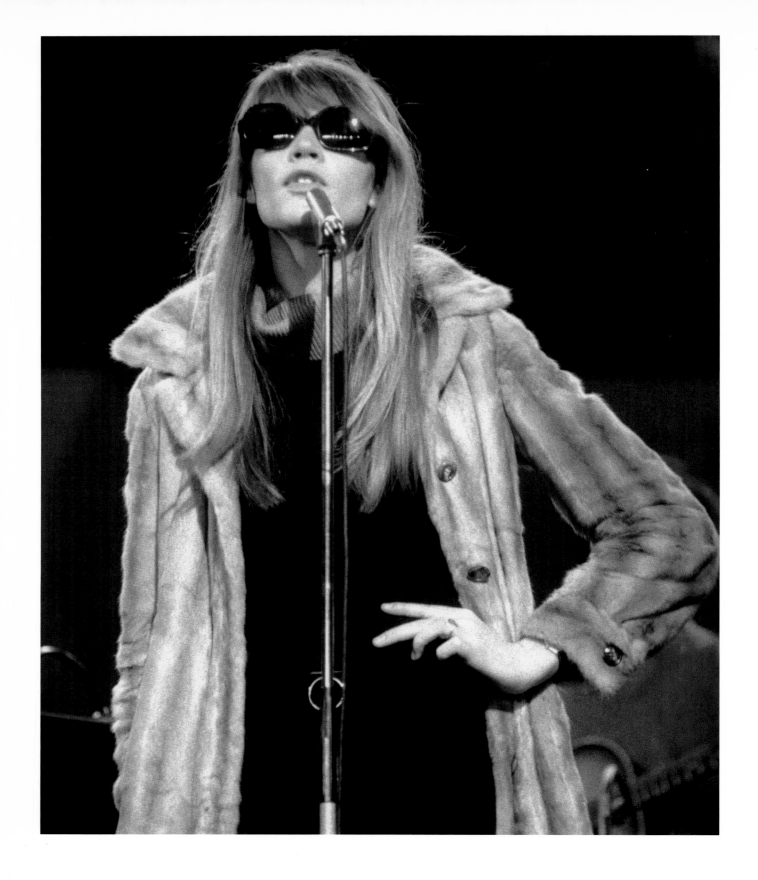

Above:
Françoise Hardy on stage, 1969.

Opposite:
Gwyneth Paltrow in Hollywood, 1995.

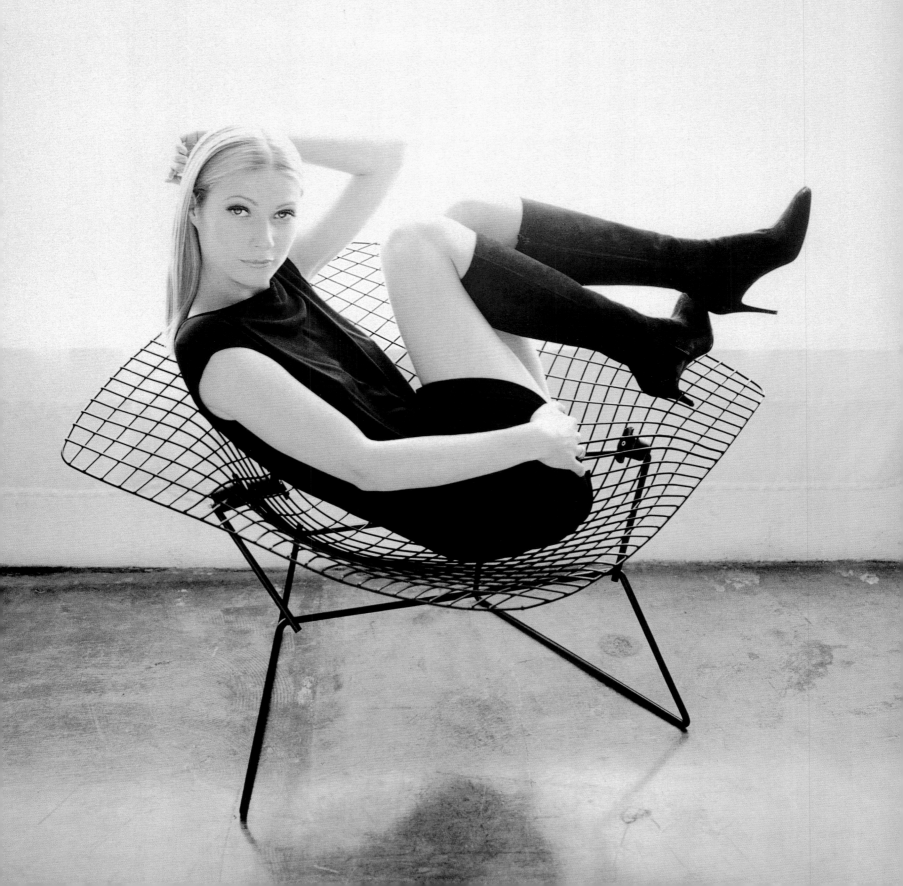

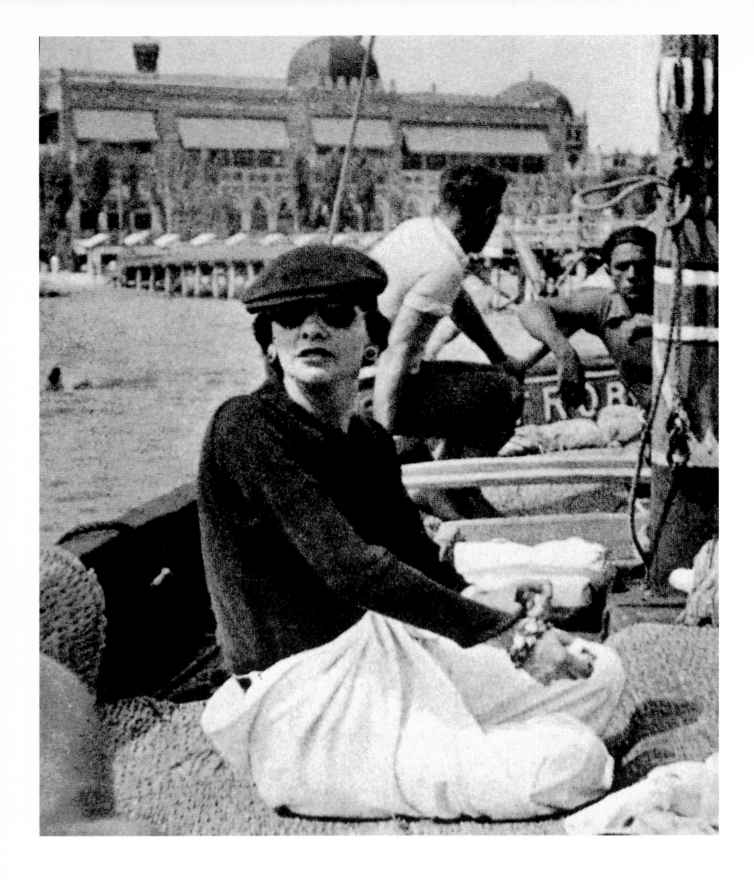

Above:
Coco Chanel, photographed by Victor Grandpierre at the Lido in Venice, 1936.

Opposite:
"Babe" (Mrs. William) Paley at home, photographed by Alexander Liberman, 1942.

Following pages:
Nan Kempner, Fran Stark, and Jacqueline de Ribes chatting at a Metropolitan Opera benefit dinner, New York, 1984.

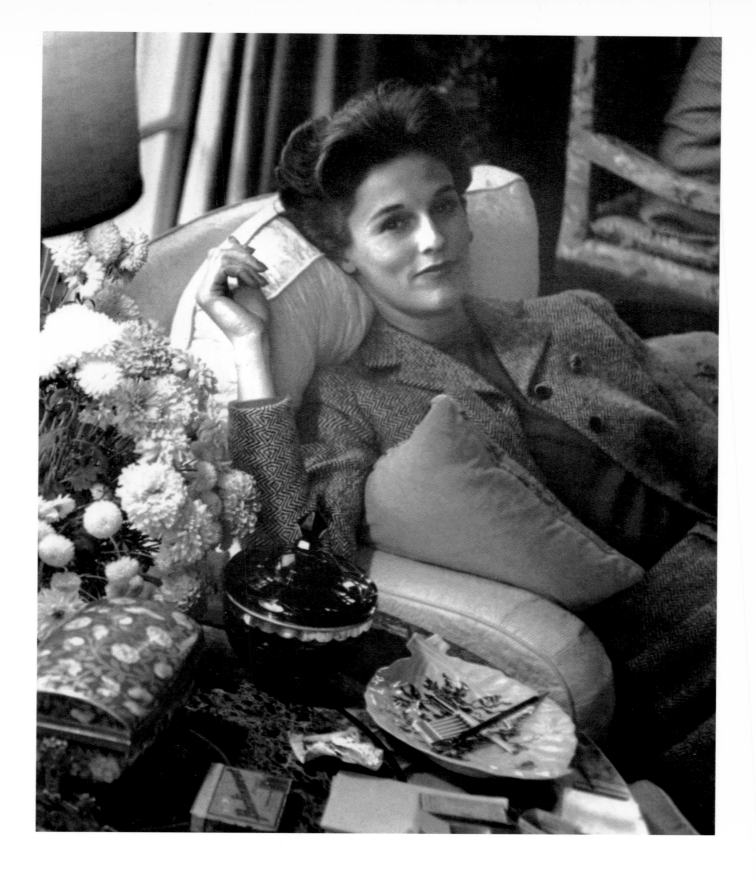

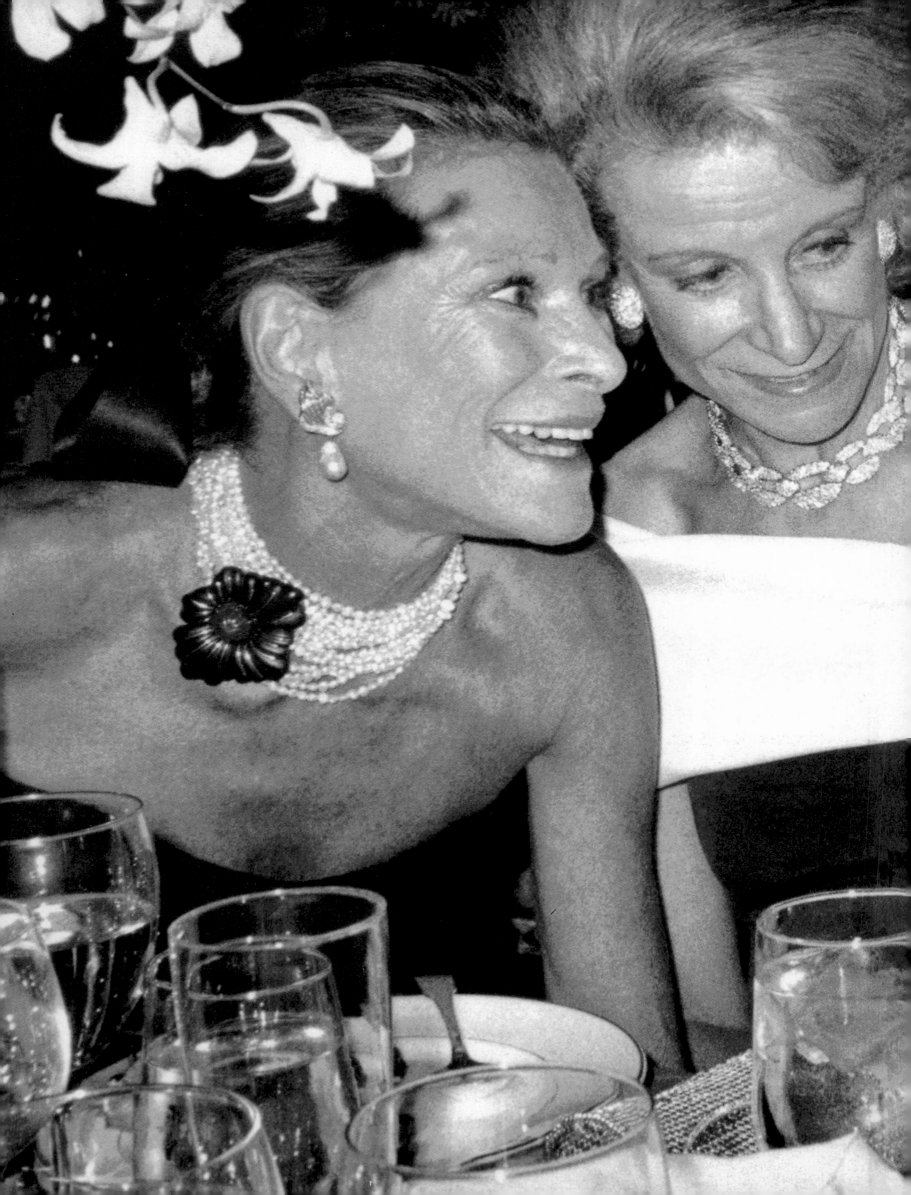

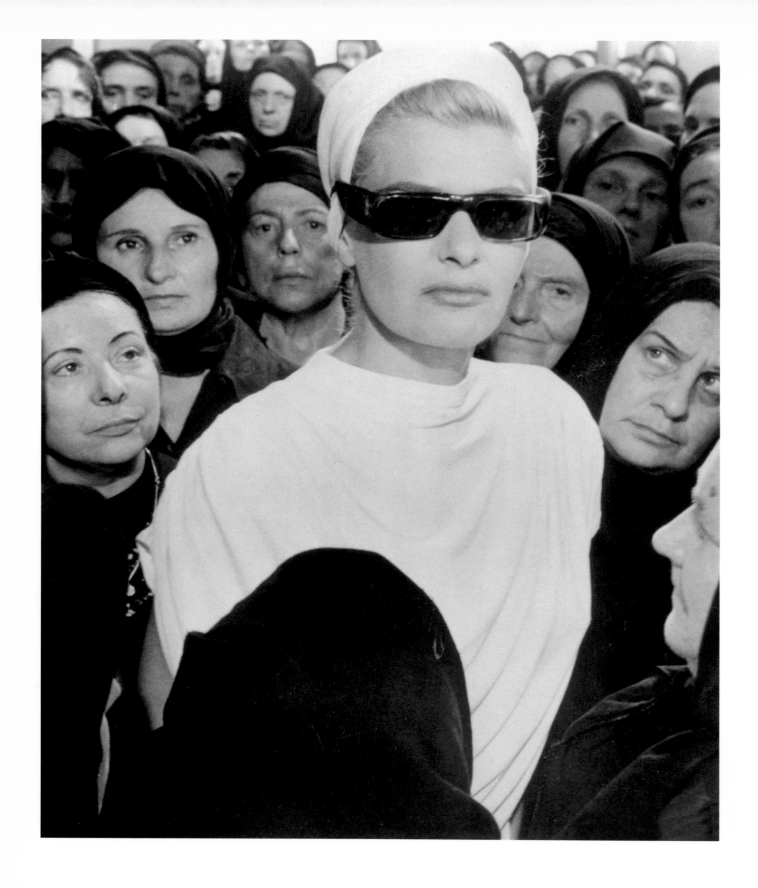

Above:
Film star Melina Mercouri on the set of Jules Dassin's *Phaedra*, 1961.

Opposite:
Nancy Cunard and Tristan Tzara, photographed by Man Ray
at the opening of a ball given by Comte Etienne de Beaumont in 1924.

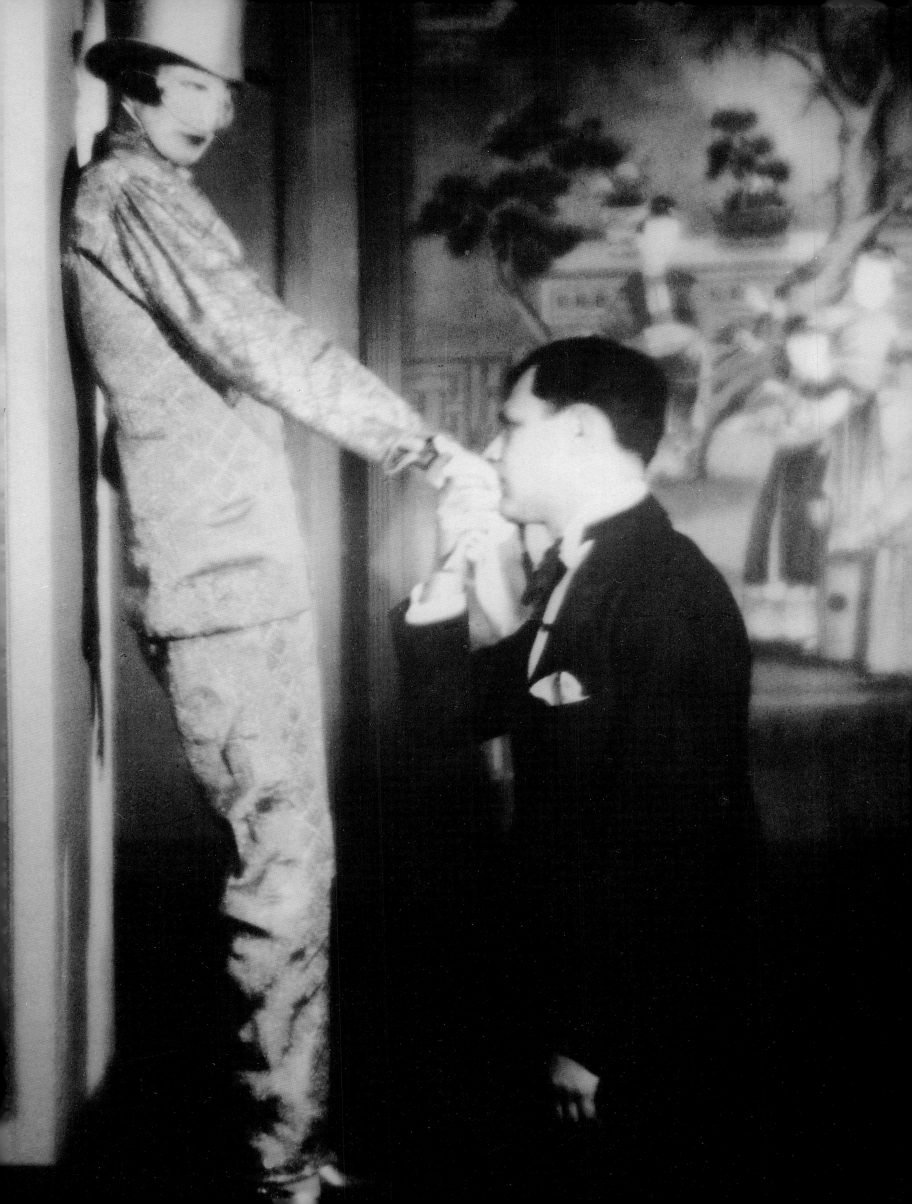

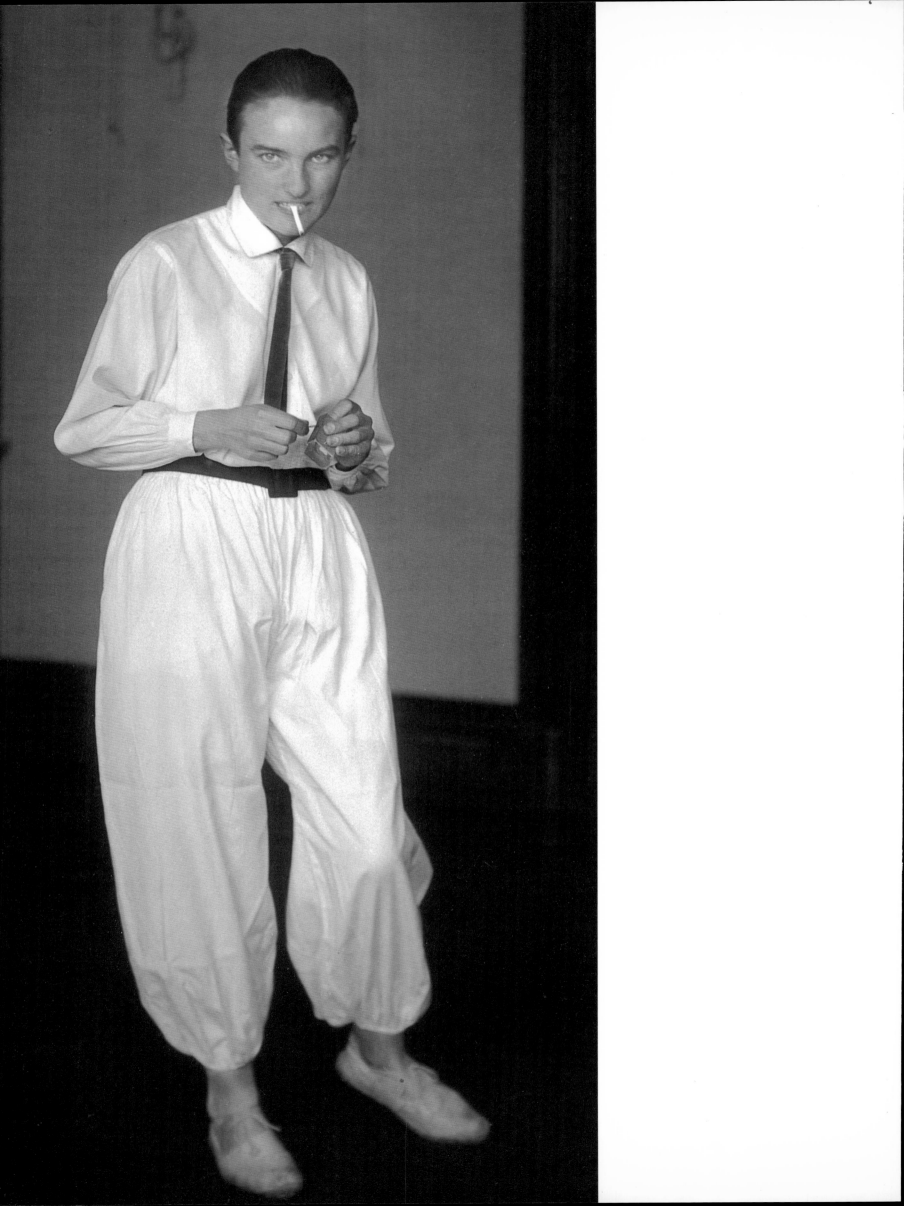

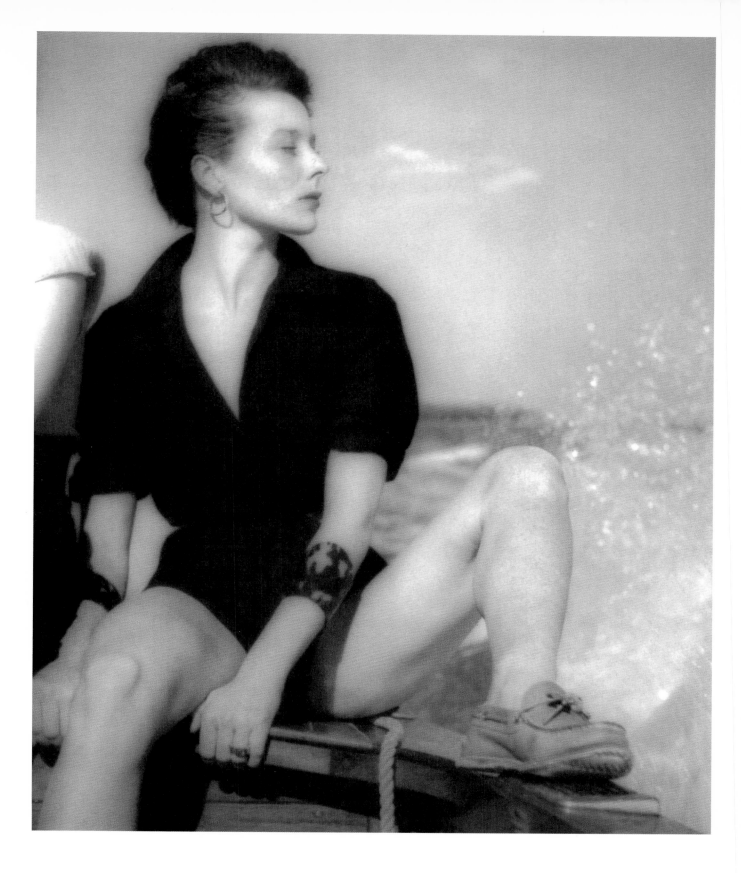

Opposite:
Mrs. Peter Abelen, photographed by August Sander, 1926.

Above:
Fashion model Bettina, photographed
at sea by her friend Roger Prigent, 1960s.

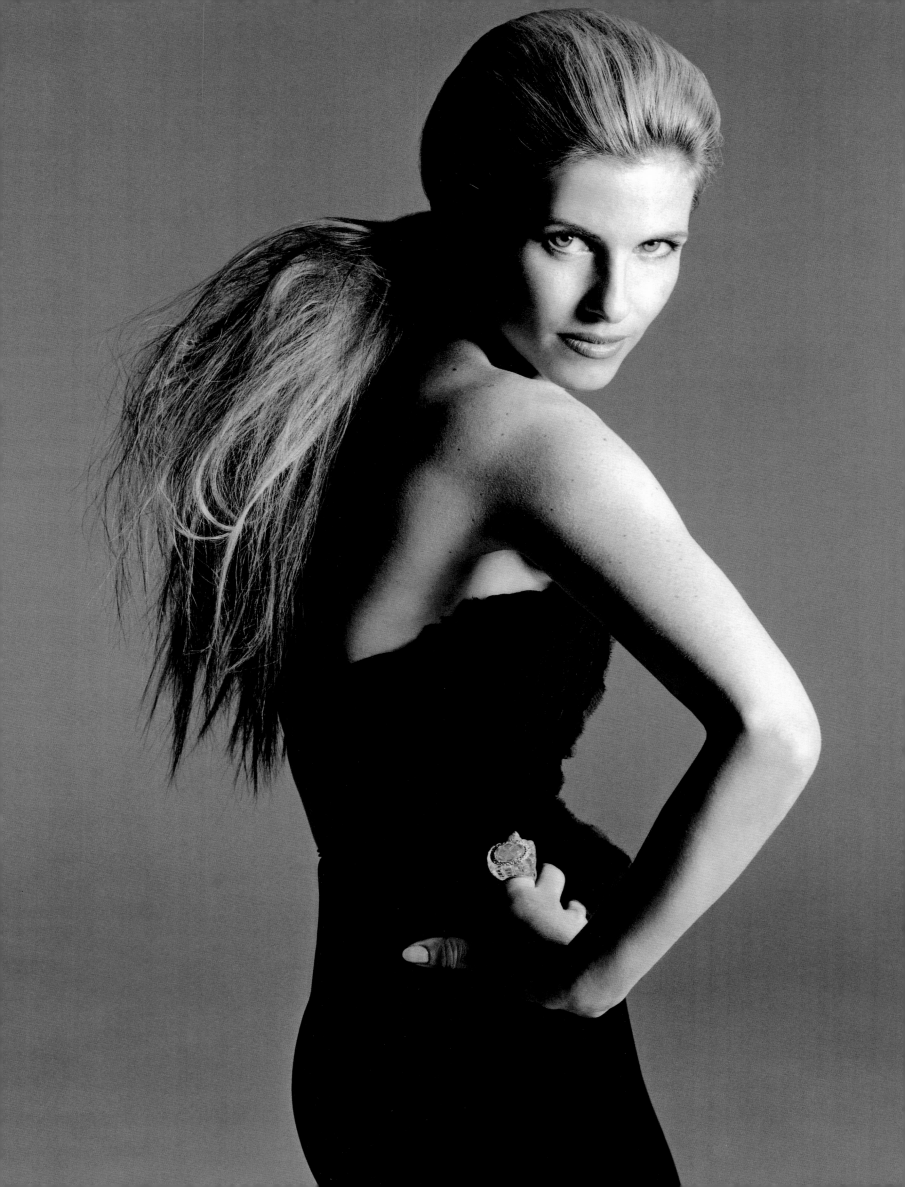

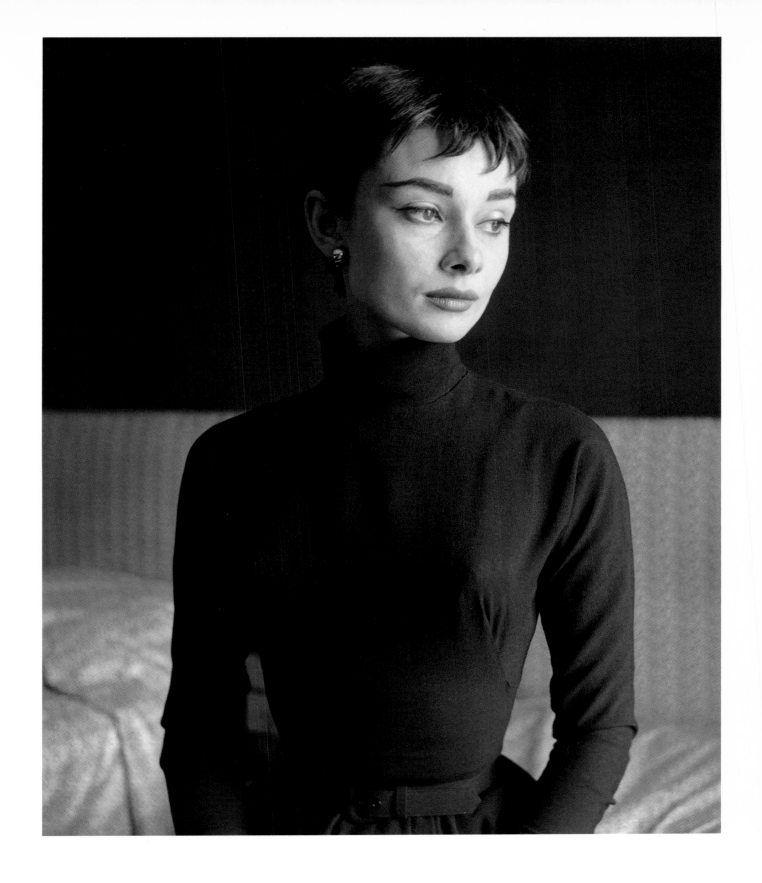

Opposite:
Brooke de Ocampo, photographed by Michael Thompson, November 2000.

Above:
Audrey Hepburn, by Cecil Beaton.

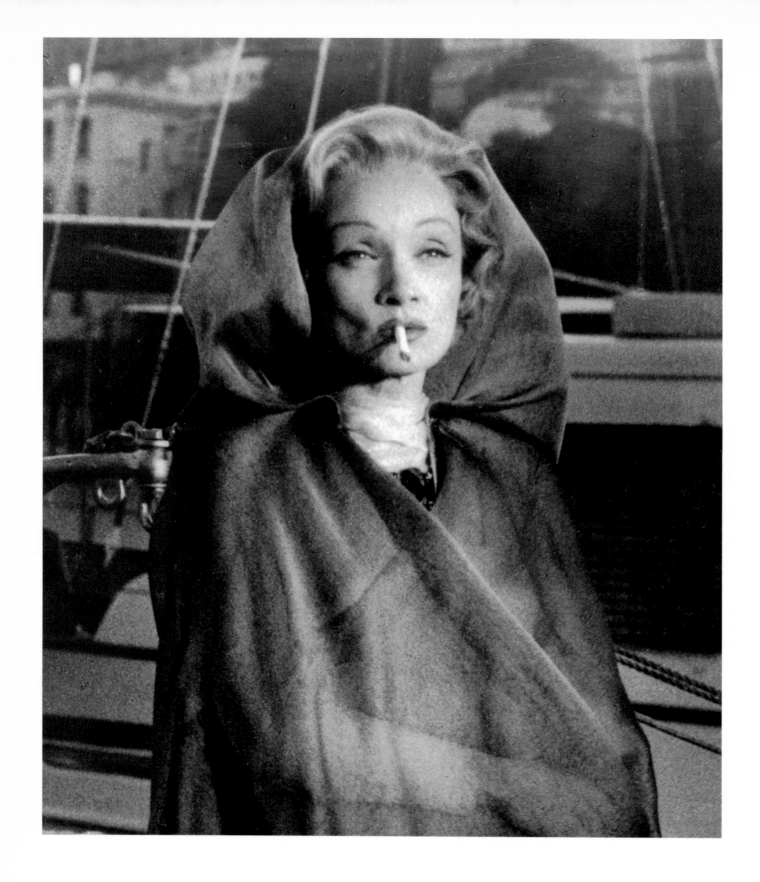

Above:
Marlene Dietrich, 1956.

Opposite:
Gong Li, Hong Kong, 1990s.

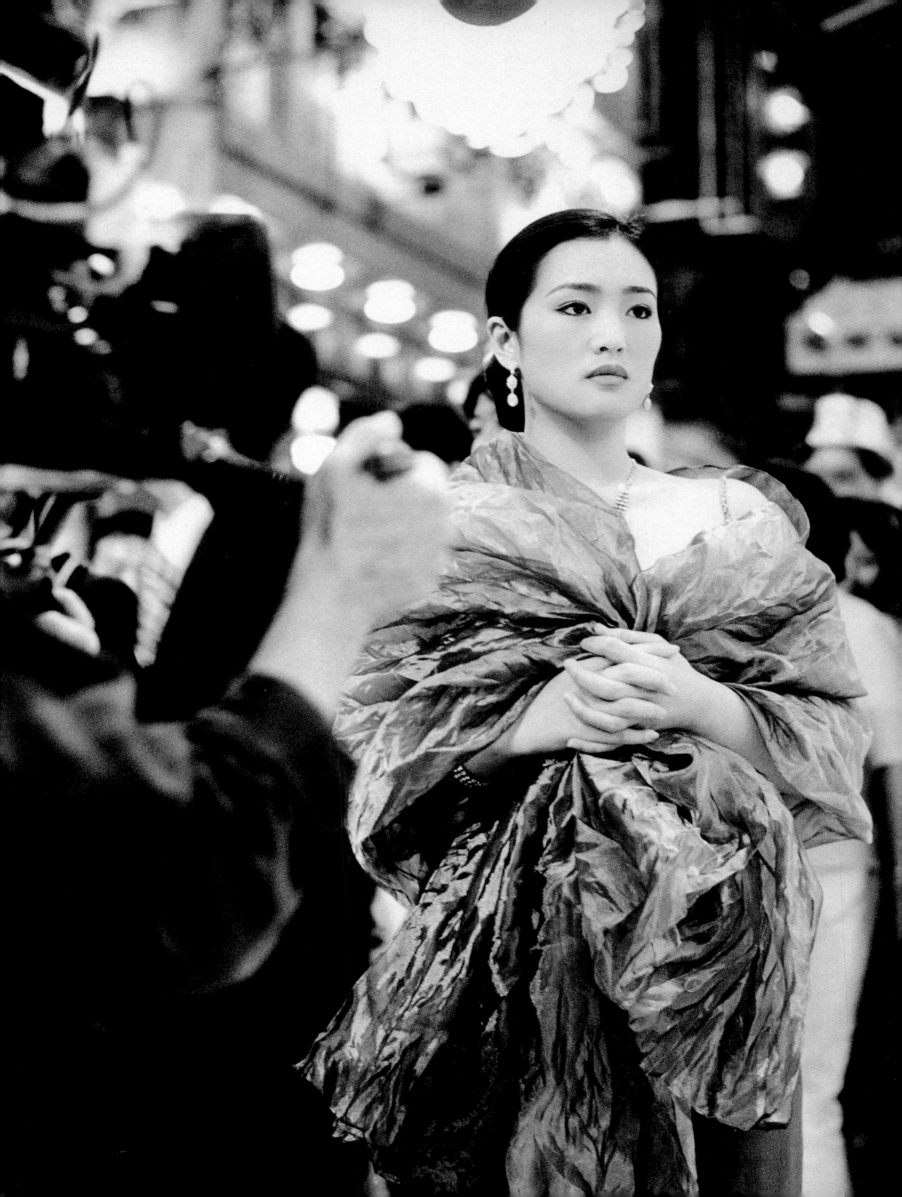

PHOTO CREDITS

ACKNOWLEDGMENTS

Our thanks to all who in one way or another have contributed to the publication of this book, with special thanks to Slim Aarons, Brigitte Bardot, Lillian Bassman, Gilles Bensimon, Mario de Biasi, Betty Catroux, Raymond Cauchetier, Michel Comte, Dominique Deroche, Wim Dewitt, Anh Duong, Loulou de la Falaise, Maxime de la Falaise, Howard Greenberg, Timothy Greenfield-Sanders, William Klein, Christophe Kutner, Inès de La Fressange, Karl Lagerfeld, Roxanne Lowitt, Sarah Moon, Kate Moss, Helmut Newton, Brooke de Ocampo, Paloma Picasso, Eric Pfrunder, Andrée Putman, Charlotte Rampling, Michael Roberts, Carine Roitfeld, Mario Testino, Michael Thompson, Ruben Toledo, Deborah Turbevill and Nicole Wizniack, ainsi que Susan et Stephan (Filomeno), the Howard Greenberg Gallery, the Estate of Robert Mapplethorpe and the Estate of Alexander Liberman.